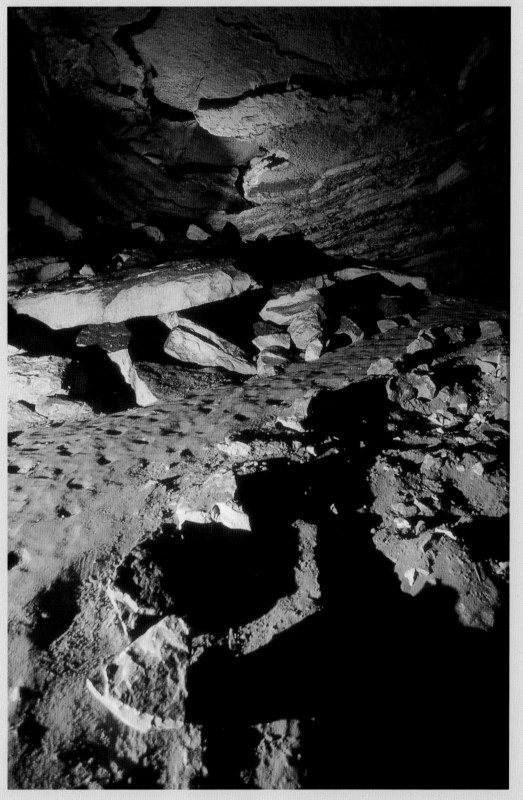

Mammoth Cave National Park

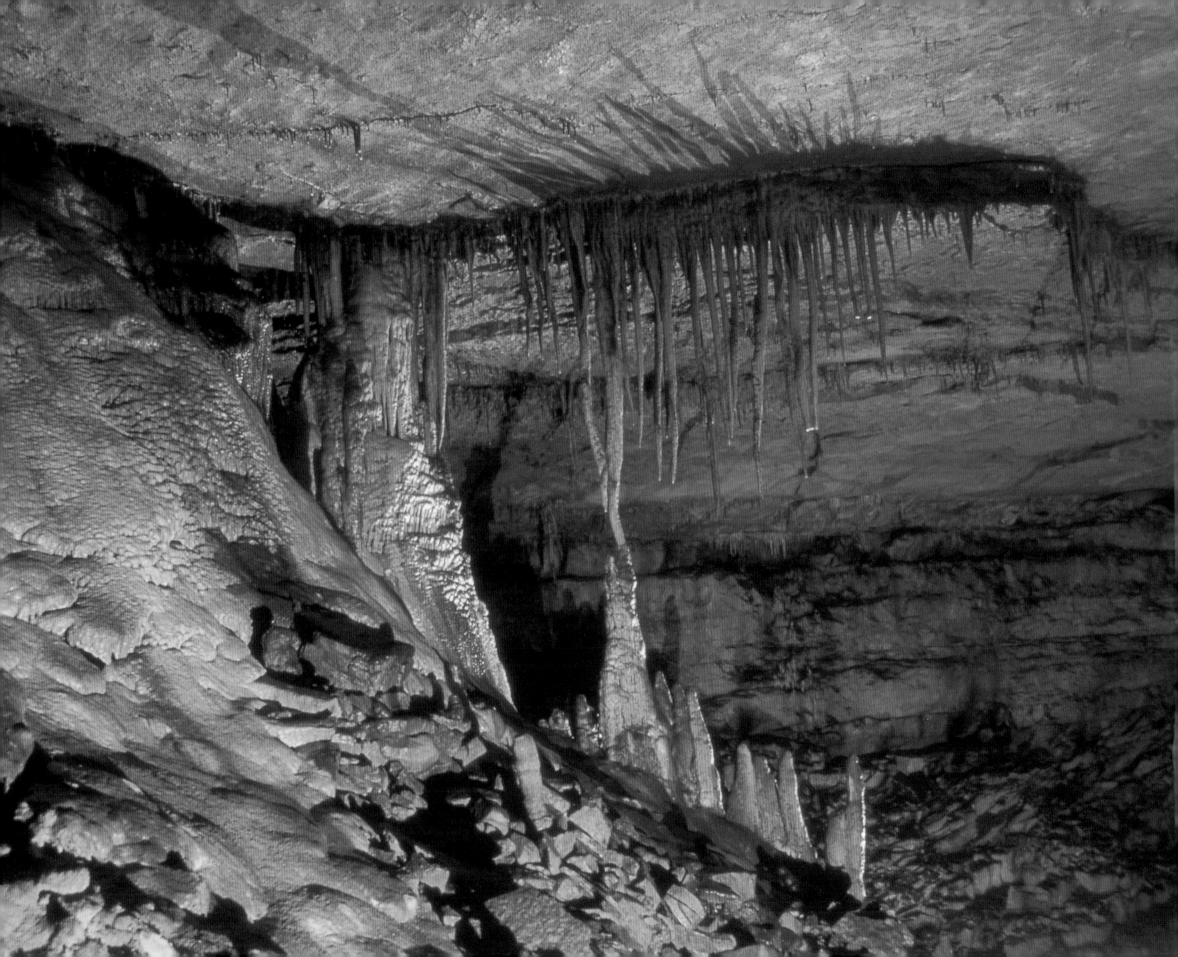

Mammoth Cave National Park Reflections

RAYMOND KLASS With a Foreword by Ronald R. Switzer

THE UNIVERSITY PRESS OF KENTUCKY

Publication of this volume was made possible in part by a grant from the National Endowment for the Humanities.

The University Press of Kentucky
Scholarly publisher for the Commonwealth,
serving Bellarmine University, Berea College, Centre
College of Kentucky, Eastern Kentucky University,
The Filson Historical Society, Georgetown College,
Kentucky Historical Society, Kentucky State University,
Morehead State University, Murray State University,
Northern Kentucky University, Transylvania University,
University of Kentucky, University of Louisville,
and Western Kentucky University.

Editorial and Sales Offices: The University Press of Kentucky
663 South Limestone Street, Lexington, Kentucky 40508-4008
www.kentuckypress.com

09 08 07 06 05 5 4 3 2 1

Frontispiece: Violet City formations, Mammoth Cave.

Library of Congress Cataloging-in-Publication Data
Klass, Raymond, 1983–
Mammoth Cave National Park: reflections / Raymond Klass;
with a foreword by Ronald Switzer.
 p. cm.
ISBN 0-8131-2353-4 (hardcover: alk. paper)
1. Natural history—Kentucky—Mammoth Cave National Park—
Pictorial works. 2. Mammoth Cave National Park (Ky.)—Pictorial
works. I. Title.
F457.M2K57 2005
917.69'7540444'02—dc22
 2004024346

This book is printed on acid-free recycled paper meeting the requirements of the American National Standard for Permanence in Paper for Printed Library Materials.

Member of the Association of American University Presses

Manufactured in South Korea.

Contents

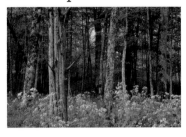
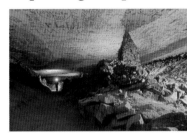
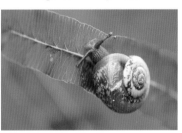
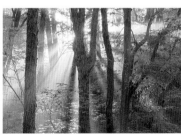
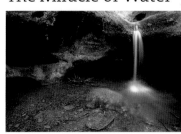

Foreword

Mammoth Cave National Park contains some of the most sublime scenery on this continent. The celebrated geology of the park and the breathtaking natural beauty of its forests and rivers make it a place of awe and inspiration. Owing to these values, the park has a place of prominence in a system of national parks containing these and other icons that have sustained public interest for generations.

The notion that Mammoth Cave and its environs are of inestimable worth to the nation as a place of renewal and recreation had its beginnings long before their establishment as a national park in 1926. The burgeoning population of the continent east of the Mississippi River had few public lands for recreation and enjoyment, and many superlative sites worthy of preservation were either too small to accommodate the spread of urbanization or already being exploited in a rapacious manner.

With the establishment of Mammoth Cave National Park, three of the East's most scenic, wild, and scientifically important natural landscapes came under federal protection. The foresight of the Appalachian National Park Commission to recommend the Great Smoky Mountains, the Shenandoah Mountains, and Mammoth Cave for inclusion in the national park system was nothing short of extraordinary. Thankfully, today we have places like these where Americans can immerse themselves in the beauty and wonder of nature and absorb the importance of these lands as valuable resources and places of renewal.

For those who have journeyed above- and belowground at Mammoth Cave, this book will serve as a visual reminder of nature's splendor. For those who have yet to visit this national treasure, let this collection of images delight your imagination with what awaits you. I hope that you enjoy this pictorial trip.

Ronald R. Switzer
Park Superintendent

Preface

This book began when I applied to become an artist-in-residence through the national park system. At the time, I had never heard of Mammoth Cave National Park and had only the vaguest idea of where Kentucky was on the map. I've come a long way since then.

Before I ever laid eyes on Mammoth Cave, I read everything I could find about the park and studied images of it. I proposed this book project before I had even stepped foot in the park, and once I got there, I was struck by the thought that if I wasn't able to produce great photographs every day, a book might not be possible. I kept a journal throughout my stay, and this is what I wrote on September 11, 2003, the day I arrived: "It is now apparent just how large a project I have started, by almost requiring myself to produce a book by the end of the seven weeks. I find the hill to producing good work only gets steeper. I will need to keep a very open mind and really concentrate on seeing shape, form, and light beyond the obvious. I'm scared, and yet excited . . . positive that I won't have any trouble for the rest of the stay finding fresh subjects."

This project started out as a personal challenge to see beyond the obvious, beyond what I had discovered the day before. Now that it's over, I've concluded that the most important part was the journey. Besides being a record of daily activities, the journal I kept offers proof that my time at the park changed me. Art can have the same effect. To a casual observer, a piece of art may be a canvas covered with paint hanging on a wall—made from materials worth only a couple of dollars. But given the means to put the work in context, to draw insight from its creator, a work of art can inspire. The value of art, like that of the park, is more than its simple existence. Its real value is its ability to influence those who see it, changing the way they perceive the world. Life is somewhat like the Mammoth Cave system: its length is uncertain, its path is winding, and anything is possible ahead. Cavers and artists alike relish that uncertainty, while striving always to move forward.

Although I am pleased with the results of my stay, it wasn't always a "walk in the park." Cave photography requires some special skills, and until you've been underground at Mammoth Cave, it's difficult to grasp just how large and cavernous it is—and how difficult it is to light. This entry is from the first day I started photographing in the cave, September 26, 2003: "Today begins week three, five more weeks seems like forever, but I still have lots to see, and even more to photograph. Appropriate for the start of a new week is the start of cave photography. . . . What a disaster that was today, my lights were all way too dim, the big flashlights ran out of power, and I haven't a clue if

I have anything decent on the film. I hope, however, that this experience is really going to help me be better prepared next time."

None of the images from that first day are included in the book. The film was almost blank, but at least the day proved to be a great learning experience.

Along the way, I had my fair share of both good and bad events. Disaster struck on day forty-six. I had finally developed a system to achieve good exposures in the difficult cave environment, but then my camera broke. This entry is from October 27, 2003: "I don't know why I'm even bothering to write a journal entry today, I think I'd rather not remember what happened. I hiked to Mammoth Dome and set up all my camera gear. My camera finally bit the dust, the shutter is dead."

The walk back to the entrance of the cave was the worst part. It took almost half an hour to lug all the equipment out while I contemplated what I would do without a camera. Luckily, my family was able to ship a camera to Kentucky quickly enough to avoid too much loss of shooting time.

One of the most memorable experiences of my trip was going caving with three people I had met in the area. Although the four of us were from slightly different backgrounds, we all shared an interest in discovering what was just beyond the next bend. We didn't find anything earth-shattering that day, but my journal entry from November 7, 2003, clearly expresses the motivation of caving and the quest for discovery anywhere: "Went caving again with Gary, Norman, and Rick. We could see the waterfall, into the pit that they'd been hearing, but we couldn't get to see over the edge. Seems we've been left with even more motivation for the next trip back."

If I had to choose just one word to summarize my entire park experience, it would be *humbling*. The part of the cave that is mapped is more than a quarter of the distance from New York to Kentucky, twisting this way and that along its five levels of passages. I was lucky enough to live alongside those who guide and protect this awe-inspiring natural feature, and I could not have met friendlier people.

As the saying goes, "A picture is worth a thousand words," but the experience of working to bring out the best qualities of Mammoth Cave National Park was worth more than all the images or all the words I could put on paper. I hope that these photographs inspire other visitors to experience the best of the park and be moved by one of the country's great natural treasures.

First Impressions

Wide, high ridges push the horizon farther and farther out of reach. The forest and hills are a magnificent sight, but even more astounding is that hundreds of feet below there's another world shrouded in absolute darkness. A cave system of incomprehensible length winds its way under these hills. It is the unique landscape aboveground that has led, over millions of years, to the creation of Mammoth Cave, the longest known cave system in the world. The landscape aboveground at Mammoth Cave National Park is as much a treasure as the giant forests of the Pacific Northwest. This is where the journey begins.

Today, it seems that I own the woods around me. A sweeping blanket of green forest greets me. The impressively vast hardwood forest covers every visible acre of land. Trees rise above to form an almost impenetrable canopy. Their branches spread this way and that, bearing leaves of every imaginable shape and size. Just when I'm wondering if light ever finds its way through, I encounter a beautiful sea of wildflowers covering the forest floor. The flowers have risen despite the giant trees soaking up the noon light. Dappled yellow and white, pink and lavender, they sway with the gentle afternoon breeze.

The trees part up ahead as the road ends at the mighty Green River. The two ferries here in the park are some of the last remaining rural ferries in use. Fallen trees stretch their powerful limbs out from both riverbanks. Fish jump and land with a splash, not unlike the sound of walnuts plummeting from the trees high above. The river reflects the colors of its surroundings. In summer, it's a brilliant green, while autumn brings bright red and orange-yellow hues so intense that it seems the water is on fire.

Hiking through the backwoods, it's easy to imagine how the frontiersmen felt hundreds of years ago, wading through wildflowers and passing trees of incredible size before meeting the shores of the Green River. A woodpecker noisily hammers a great oak above, while a fawn listens for footsteps across the forest floor. Each bend in the trail seems a mystery, promising new discovery—and another bend up ahead.

Legend has it that a frontiersman by the name of John Houchins was the first to discover the entrance to the cave while hunting. Allegedly, he shot and wounded a bear and followed it to what is now the Historic Entrance to Mammoth Cave. The first entryway section of the cave is called Houchins Narrows in his honor.

Whether the legend is true or not, the Historic Entrance is an impressive sight. Those seductive steps leading into the darkness make it almost impossible to resist the urge to explore below.

Upon descending the stairs, our little group of explorers faces the cool, crisp air of the cave—a marked contrast to the warm sun on our backs. Our eyes open wider, trying to soak up every last ray of light. The guide's lantern illuminates the way. As we pass through Houchins Narrows and into the grand Rotunda Room, the lantern light barely fills the walls. Its shifting, uneven flame only hints at the mysteries that lie ahead. The guide recounts stories of ancient explorers—a mummy discovered—and the first Native Americans to travel the tunnels, and our anticipation grows. No one knows how long Mammoth Cave is or what other artifacts still lay uncovered.

Continuing on the trail through the cave, we reach a room called The Church, famous for the sermons that were once given from Pulpit Rock. The locals take advantage of the great acoustics and hold an annual "cave sing."

We gather in the center of the room, and the guide lights a replica of the original lard oil lanterns used in the 1800s. We extinguish our lights and stand absolutely silent, listening for the sounds a cave makes. We hear nothing, and that's the point: a cave has no natural sound other than that made by water, which we are too far away to hear. More than a hundred feet below the surface, there is absolutely no light, and when the guide extinguishes the ancient lantern, everything goes black.

We walk farther into the unknown, shapes and shadows passing us by. The cave tells its own tale. Like scars, the water has left scallops and outcroppings where it once flowed through the now-dry passage. Candle writings dot the walls, the signatures of visitors and guides dating back to the early 1800s. Bits of cane reed torches used by the Native Americans still lie next to the walls where they mined gypsum.

Stepping out into the sunlight underscores the depth of the cave's darkness. Our tour covered only 3 miles of the more than 365, and I can't help but wonder what other marvels lie beneath and what treasures might be beyond the surveyed passages.

Mammoth Cave contains a great diversity of passages. Some are so wide that it's impossible to see the other side; others, like Fat Man's Misery and the Mole Hole, can be a tight squeeze. The majority of the cave lacks formations, because a sandstone and shale caprock protects the passages from water, but areas such as the famous Frozen Niagara and Drapery Room boast a grand wall of flowstone and various other stalactites and stalagmites.

Each experience on the trails through Mammoth Cave National Park is unique. Before arriving, I

had read about the park and talked to people who worked there, so I thought I knew what to expect. But I couldn't have been prepared for the pristine beauty.

First impressions are a funny thing, and they can sometimes be deceiving. It's a shame that we often don't have enough time or enough motivation to really get to the heart of things. Mammoth Cave is a good example. The tour books would have you believe that the park can be seen in just a day or two, and I was worried that I might run out of things to photograph. But now I realize that I have only scratched the surface. It's a daunting task to find the 1/125th of a second that captures the essence of the natural world; to find just the right vantage point on the miles of backcountry trails. But I am excited to begin.

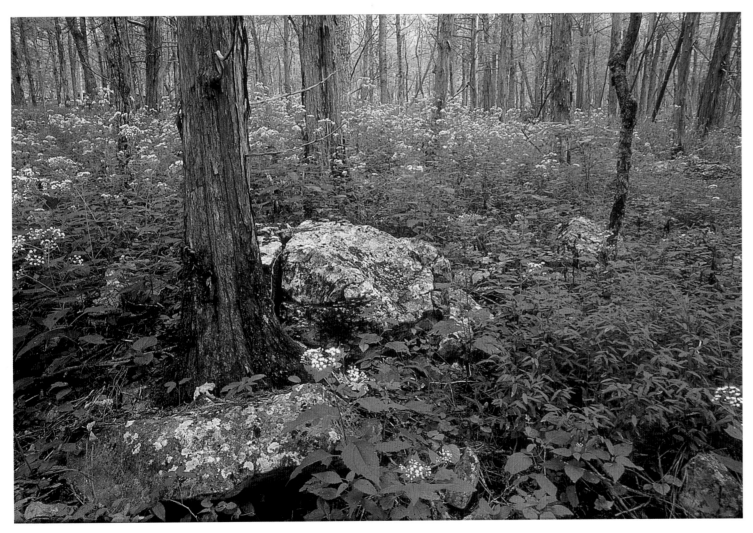

White snakeroot field with cedar,
Echo River Springs Trail

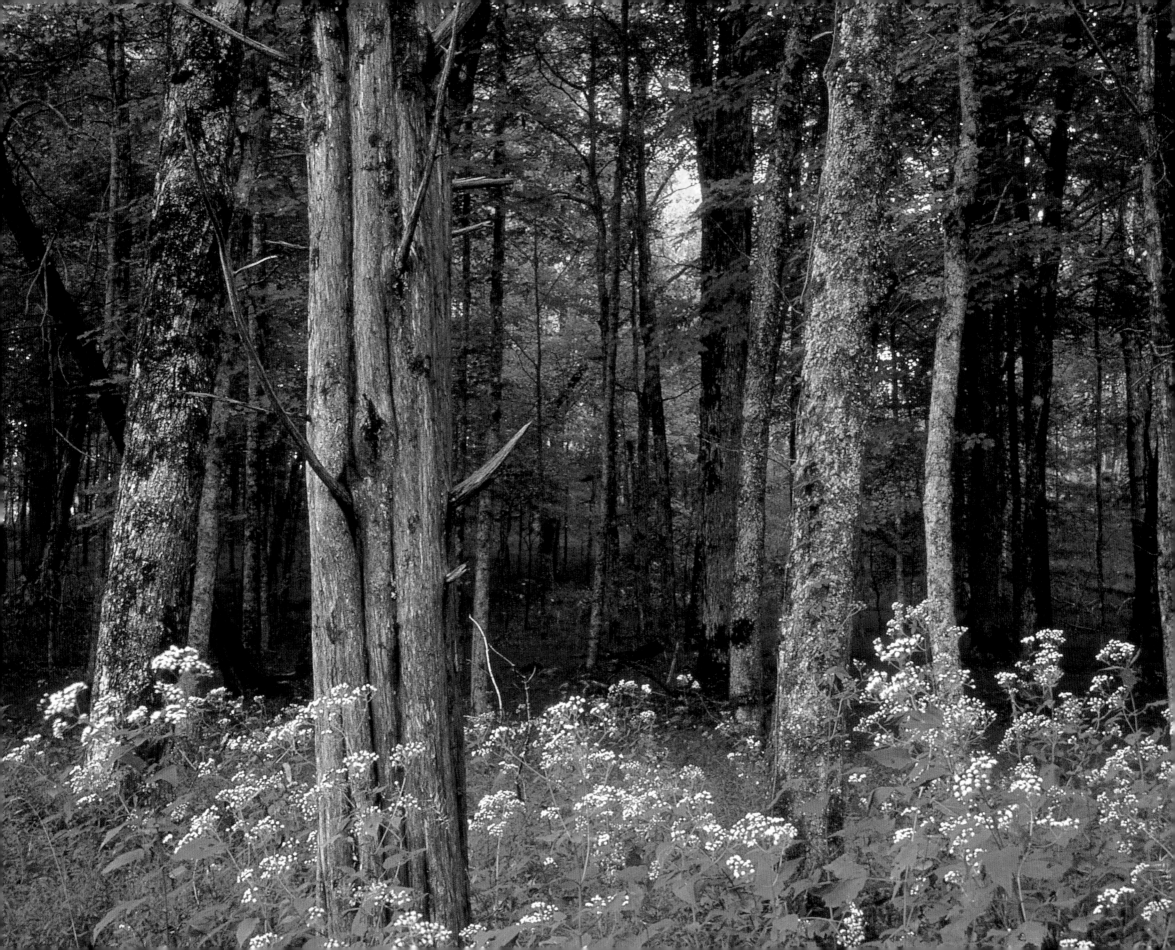

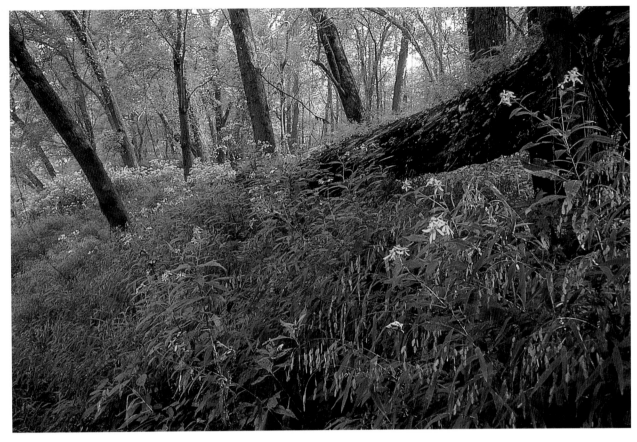

South bank of the Green River, Echo River Springs Trail

Cedar, oak, maple, and tulip in white snakeroot,
Mammoth Dome Sink Trail

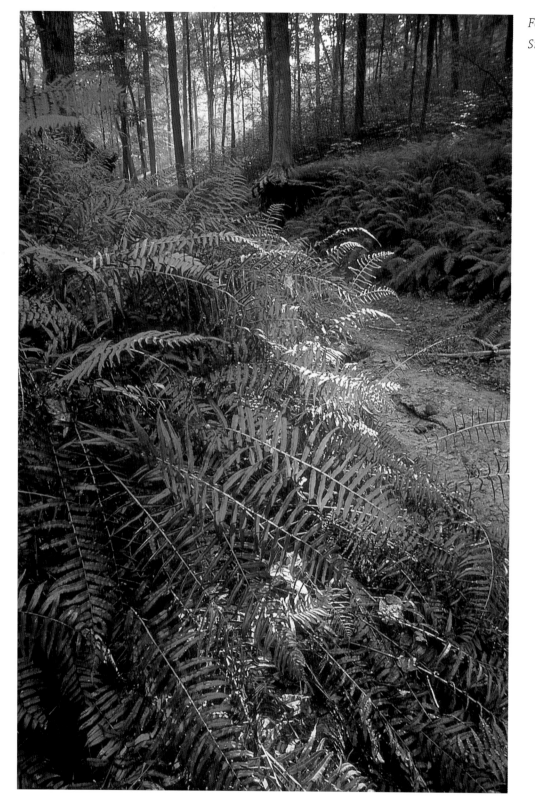

Ferns, Mammoth Dome
Sink Trail

Sunrise through oak,
tulip, maple, and hickory,
Green River Ferry Road

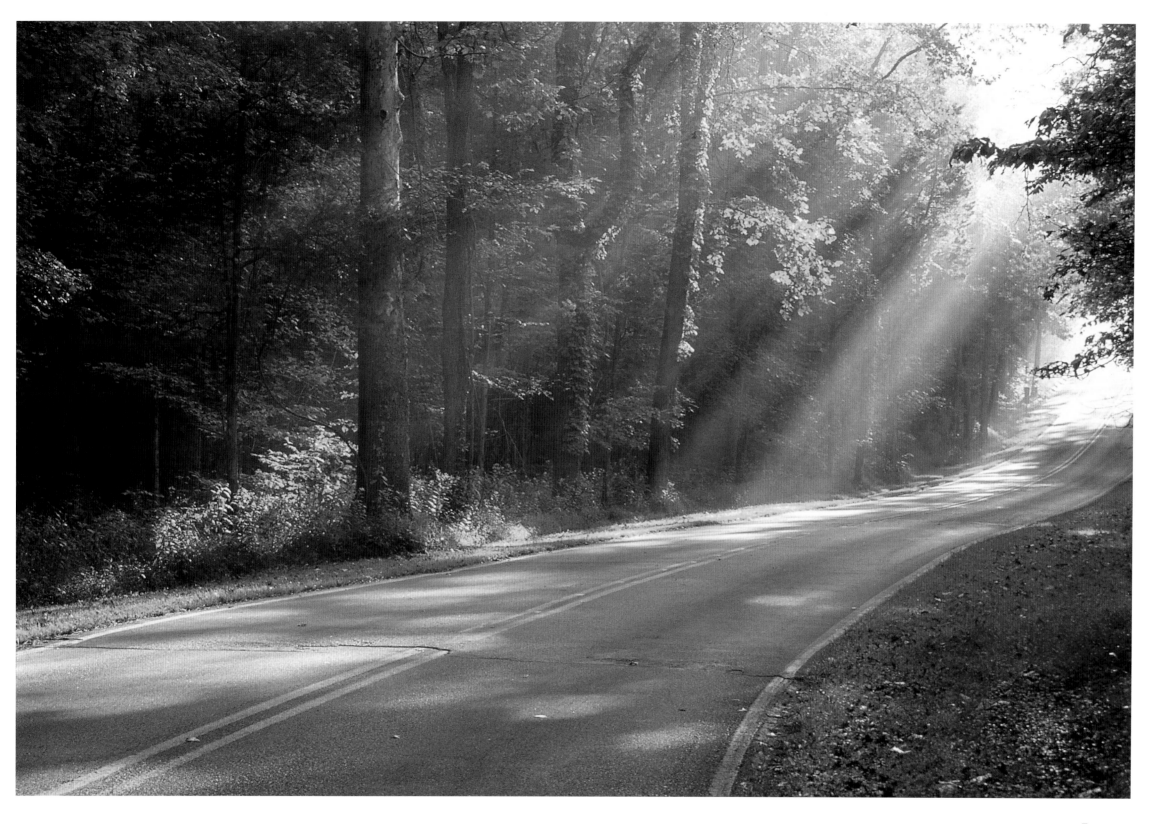

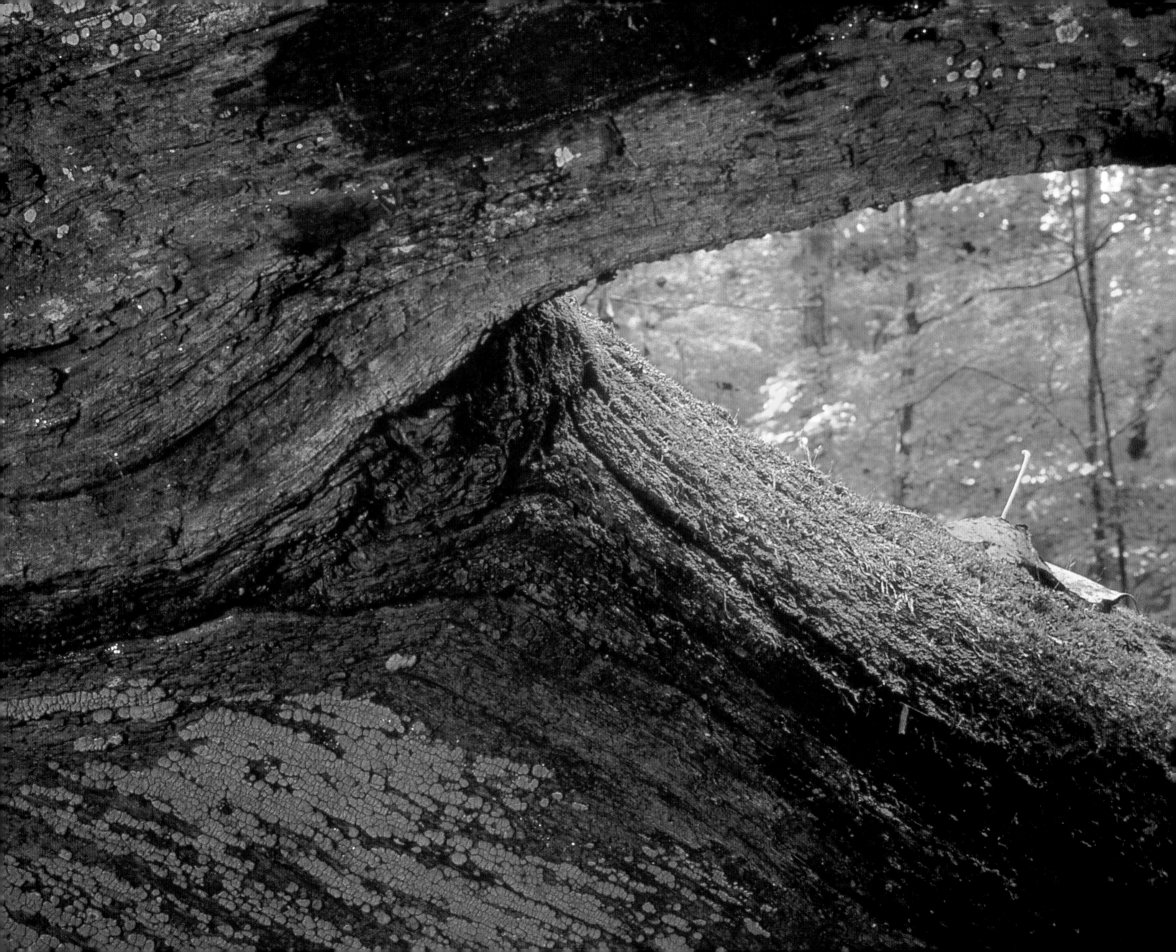

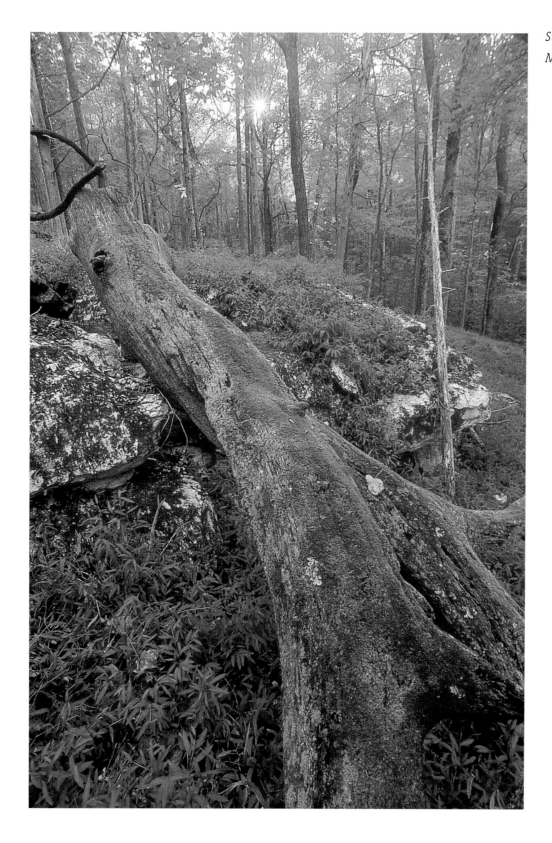

Partially decayed tree trunk,
Mammoth Dome Sink Trail

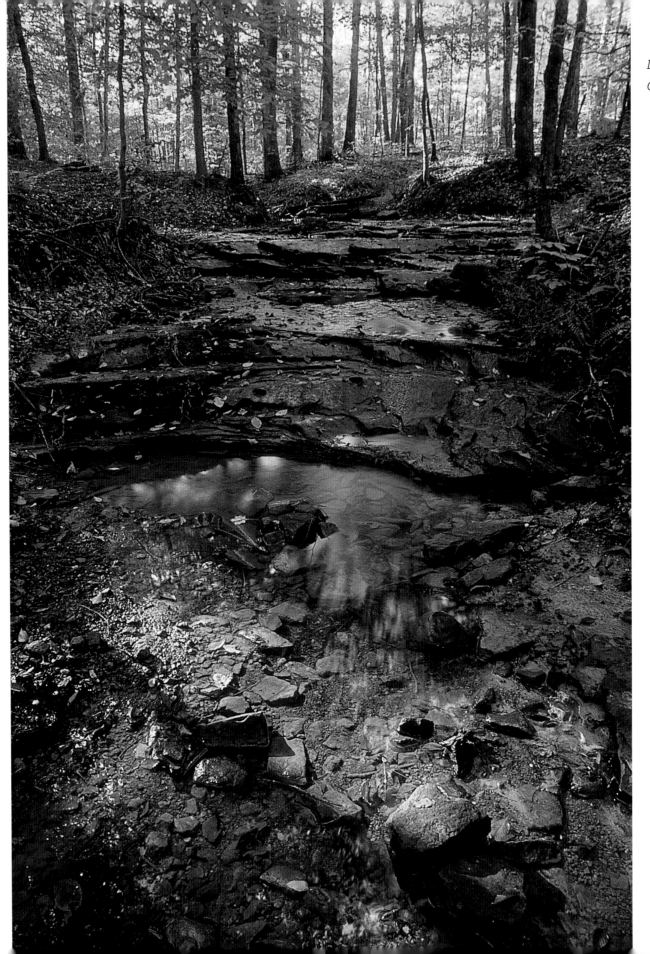

Dry Prong of Buffalo Creek,
Good Spring Loop Trail

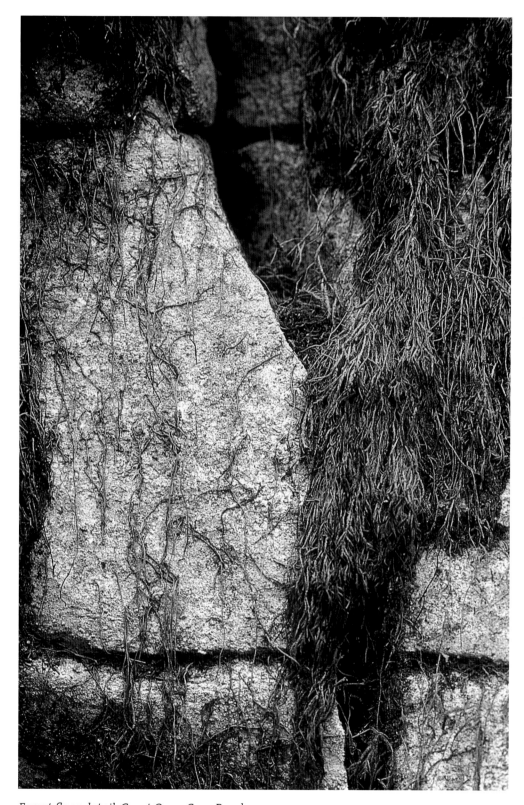

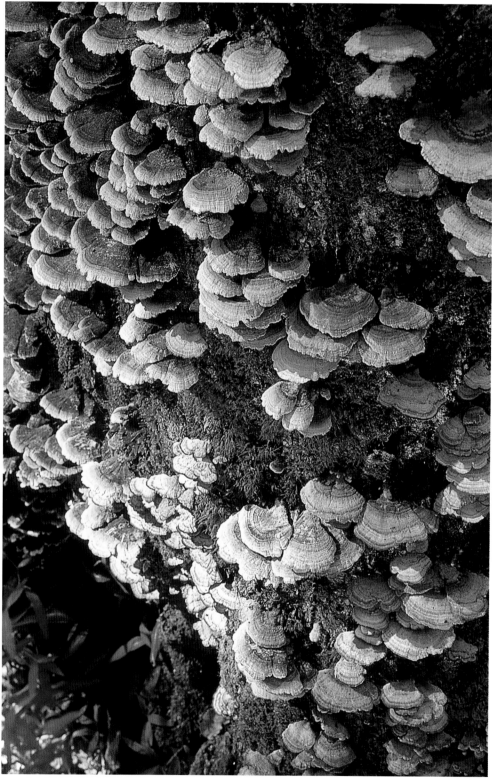

Forest floor detail, Great Onyx Cave Road

Bracket fungi, Echo River Springs Trail

Pink smartweed, Three Sisters Hollow

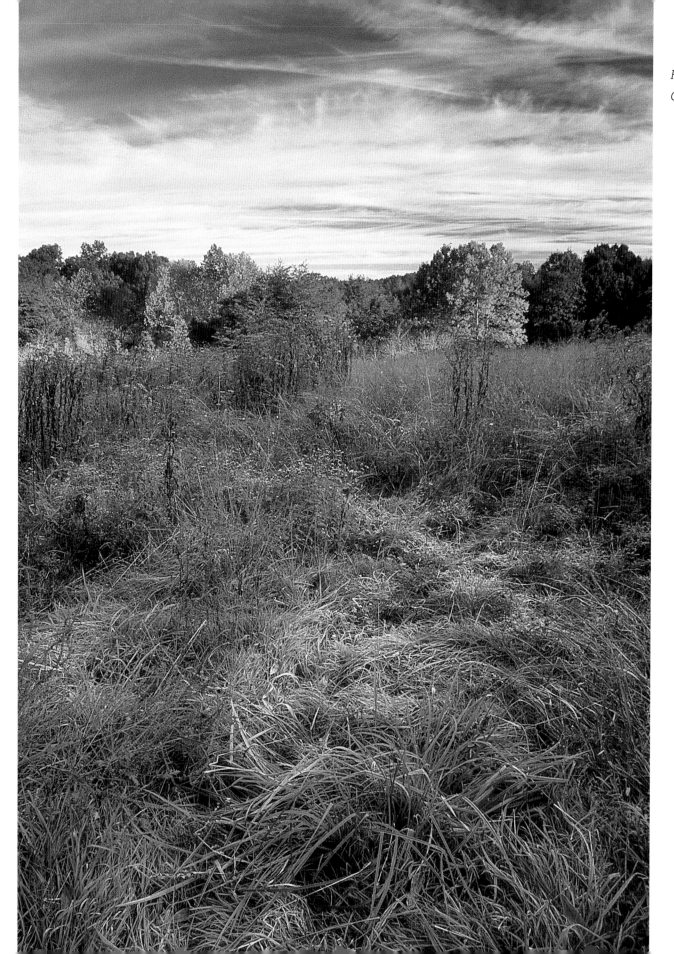

Frost-covered field,
Great Onyx Cave Road

Sunrise through oak and hickory forest, Mammoth Dome Sink Trail

Entrance to an unnamed cave near Three Sisters Hollow

14

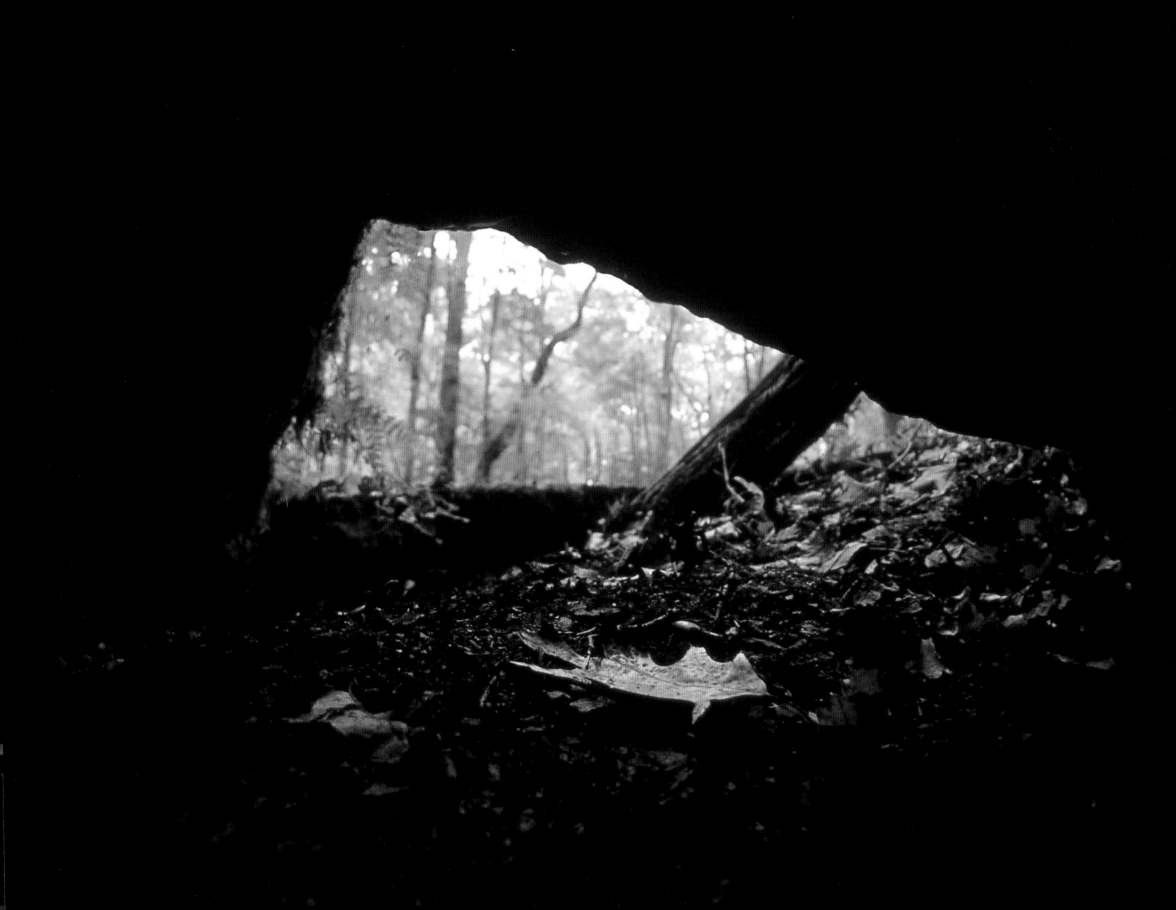

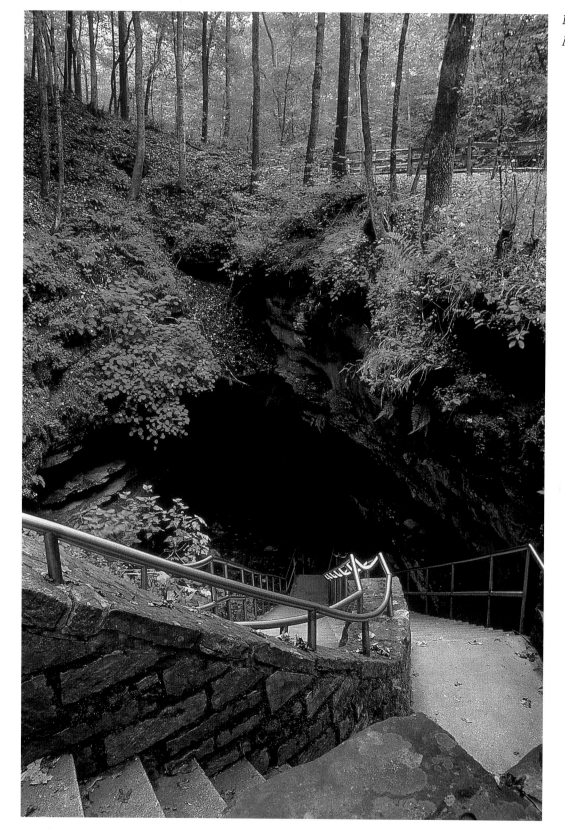

16

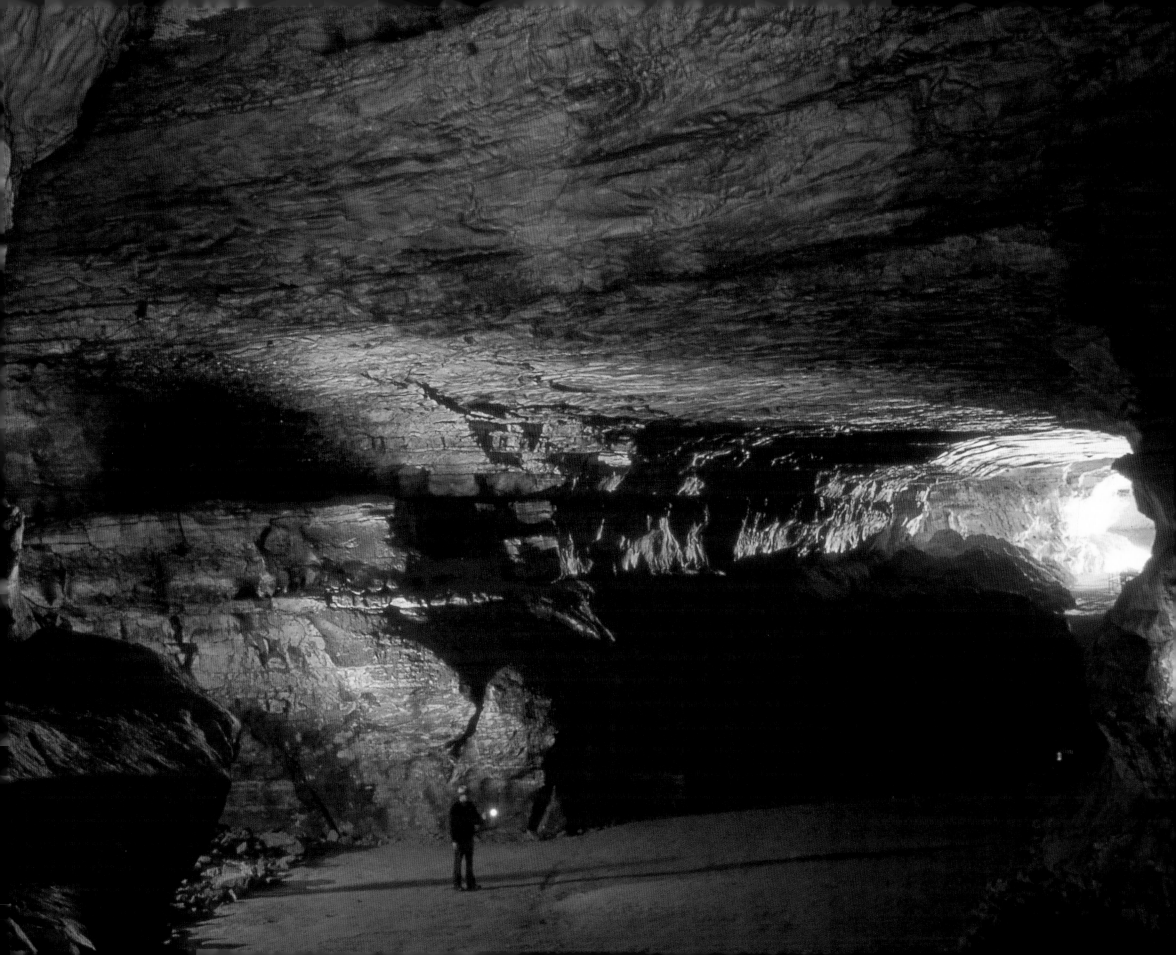

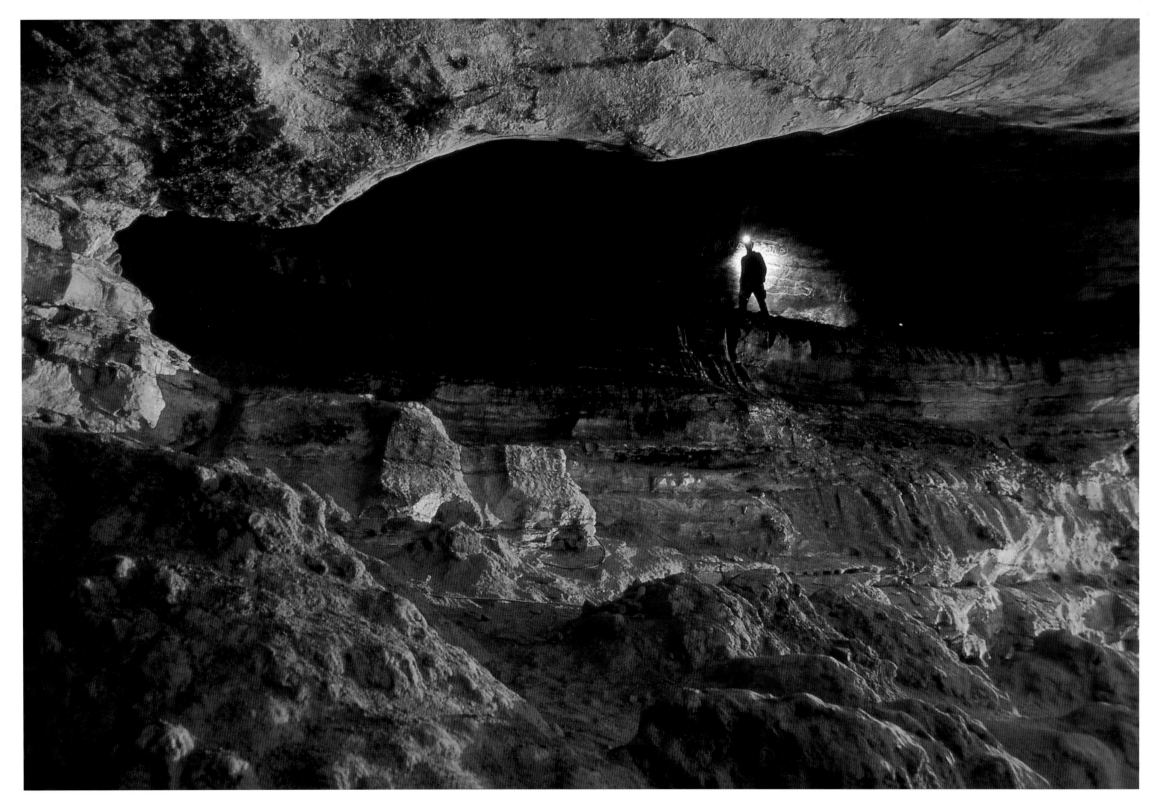

View from Booth's Amphitheatre, Mammoth Cave

Exploring Deeper and Deeper

An eerie squeak resounds off solid limestone walls that disappear into the endless darkness. With a reassuring gesture, the guide leads our group through the environmentally sound gate that divides the aboveground and belowground portions of Mammoth Cave. Looking back, I can vaguely discern the shadows of others behind me, silhouetted against the blaring midday sun.

In this unfamiliar environment, my senses strain to decipher the new surroundings. The sounds of footsteps resonate, the outcroppings of rock seem to pulsate, and the walls are striped with shadows and the orange-yellow glow of our lanterns, creating a maze of dark and light. Air whisks past, ruffling my clothes, and the lanterns flicker. The imagination soars in such an environment, and this is the lure of caving.

Caves are inhospitable places, with unforgiving terrain, tight spaces, slippery slopes, high ledges, and bone-chilling temperatures. Yet every year, thousands of people explore caves, lured by the call of the unknown. I finally understand, for as my group enters the large Rotunda Room, named for the enormous circular striations in the ceiling, my worries leave me, and all that's left is my thirst to see it all.

The people who walk the cave every day use a simple system of formations, legends, and nicknames to describe where they are. Our guide halts at The Church, named for its signature formations; on one side is the pulpit with an organ loft above it, and the other side looks as if it could seat hundreds of worshippers.

Since the National Park Service has run Mammoth Cave, it has implemented rules to protect its resources, educated its guides about historic and geologic concerns, and encouraged visitors to learn about the unique ecosystem that is Mammoth Cave National Park. Although most visitors enjoy the modern amenities the park service has installed, some prefer the unique experience of the Wild Cave Tour. All summer long, these tours, which offer climbing, crawling, and exploration, are booked to capacity with visitors looking for an authentic caving experience.

In the mid- to late 1800s, a cave tour was an entirely different experience. The trails were barely maintained, and modern conveniences such as restrooms were absent. Before the cave was a national park, it was an amusement. Guides would keep people entertained with novel tricks; for example, one part of a tunnel, if lit just right, glowed with the bust of Martha Washington. Another tradition from the 1800s was candle writing. In exchange for a tip, guides would use the smoke put

off by candles to "write" visitors' names on the ceilings or walls. These writings now help historians gauge the type and number of people who visited Mammoth Cave early on.

In 1844, Alexander Clark Bullitt described in his book *Rambles in the Mammoth Cave* his experience on a signature passage of the popular Historic Tour:

> The Winding Way is one hundred and five feet long, eighteen inches wide, and from three to seven feet deep, widening out above, sufficiently to admit the free use of one's arms. It is throughout a perfect zig-zag, the terror of the Falstaffs and the ladies of "fat, fair and forty," who have an instinctive dread of the trials to come, and are well aware of the merriment that their efforts to force a passage will excite among their companions of less length of girdle. Into this winding way, we entered in Indian file, and turning our right side, then our left, twisting this way, then that, had nearly made good the passage, when our fat friend, who was puffing and blowing behind us like a high pressure engine, cried out "Halt, ahead there! I am stuck as tight as a wedge in a log!" Halt we did, when the guide, looking at our friend, who was in truth wedg'd in the rocky way and sticking fast, cried out, "I told you when you said, at the Pine Apple Bush, that you felt especially happy, to wait till you got to the Winding Way, to see how you would feel then!" The imprisoned gentlemen soon burst his bonds, not, however, without damage to his indispensables; and at length forced his way into Relief Hall. (pp. 71–72)

Although the author may have exaggerated his fat friend's predicament, Fat Man's Misery is marked by constantly lowering and narrowing walls.

Traditionally, guides have been a resource for educating visitors about the culture and history of the park. The Native Americans mined gypsum and other minerals, and slaves extracted saltpeter, used to make gunpowder, during the War of 1812. Guides began giving tours soon after the profitability of mining decreased.

Visitors today pass by the historic remnants of two structures used more than a hundred years ago by Dr. Croghan, a prominent physician who conducted experiments in treating consumption patients in the cave. He hypothesized that the stable, cool environment of the cave would help his patients' lungs, but the damp air only worsened their condition. In fact, Dr. Croghan himself died of consumption.

At a surveyed length of more than 365 miles, and growing with each expedition, Mammoth Cave is almost incomprehensible. It extends underground in a dizzying labyrinth of tunnels, collapses, and pits. The guides who have led people through the cave for years have a legendary skill for

memorizing its trails and passages. A young Stephen Bishop, one of the most famous guides, ex-plored much of the trail system that is now used for tours.

Even today, no one has found the end of the cave. For me, the essence of the cave lies in the ex-citement of following a path carved millions of years ago by water and the anticipation of not knowing what might be up ahead.

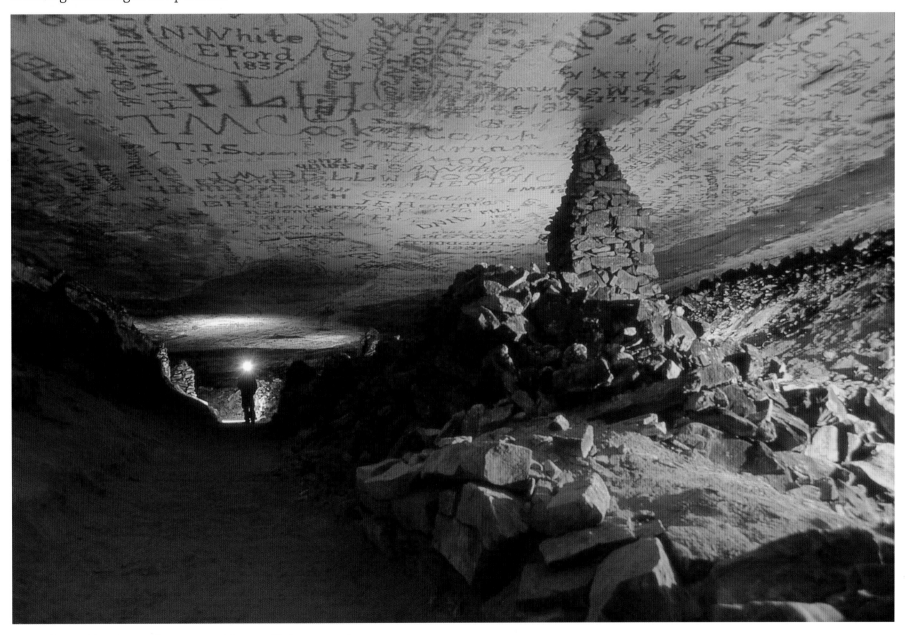

Kentucky Monument, Gothic Avenue, Mammoth Cave

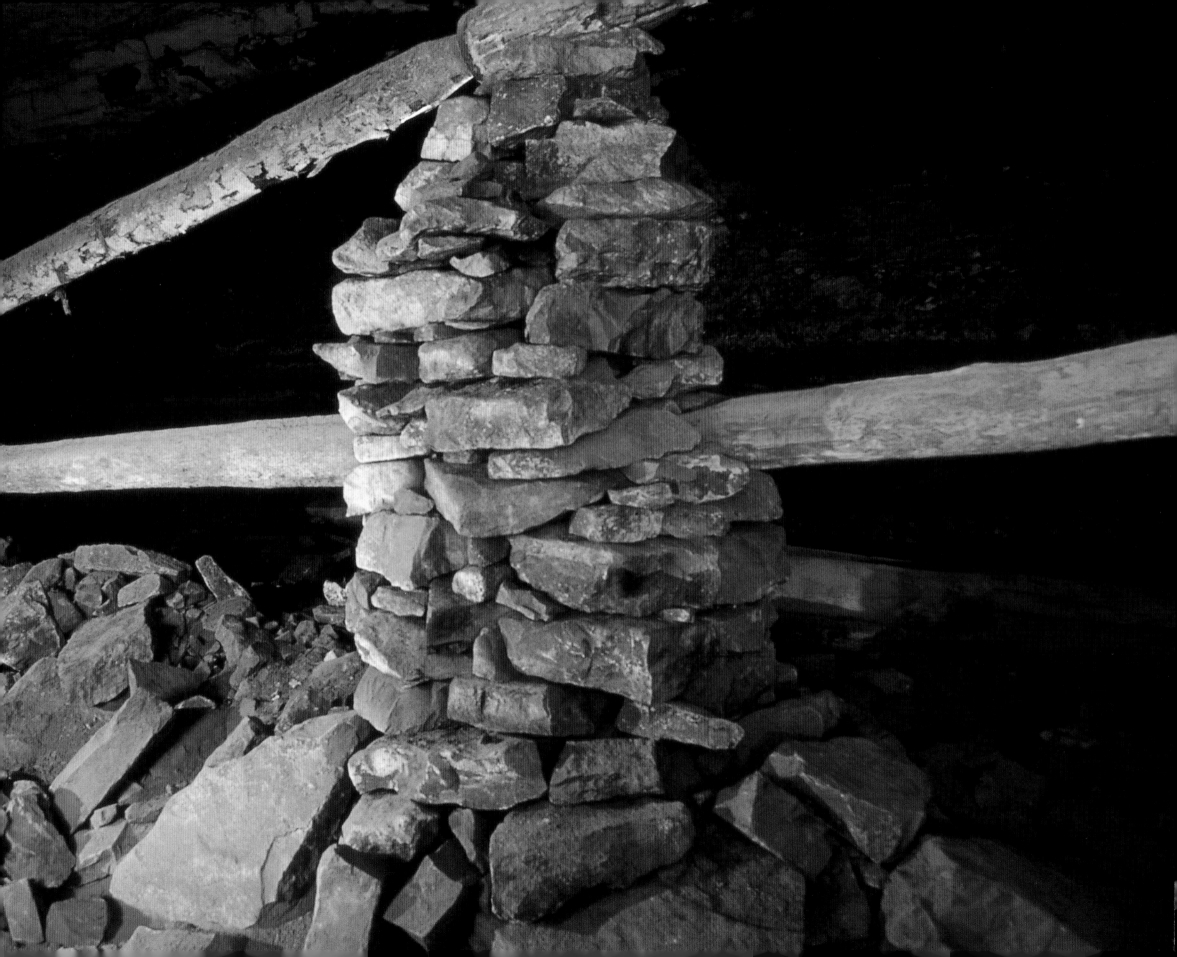

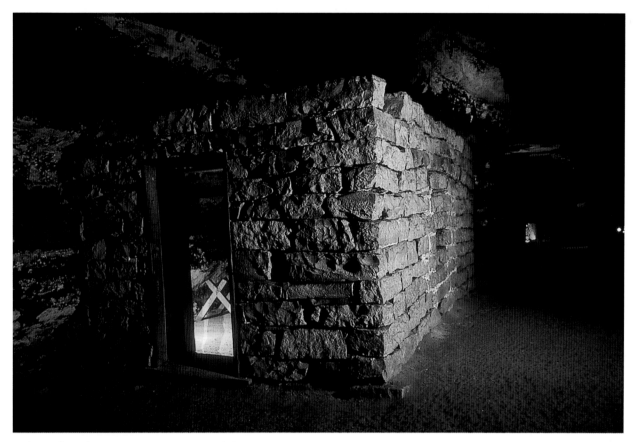

Tuberculosis huts, Main Cave, Mammoth Cave

Pipes used in saltpeter production, Mammoth Cave

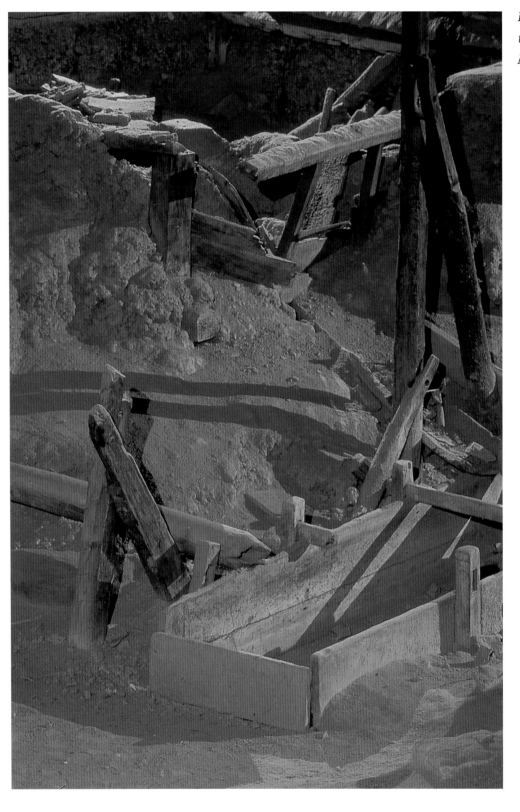

Leaching equipment used in saltpeter production, Mammoth Cave

Stalactites, Drapery Room, Mammoth Cave

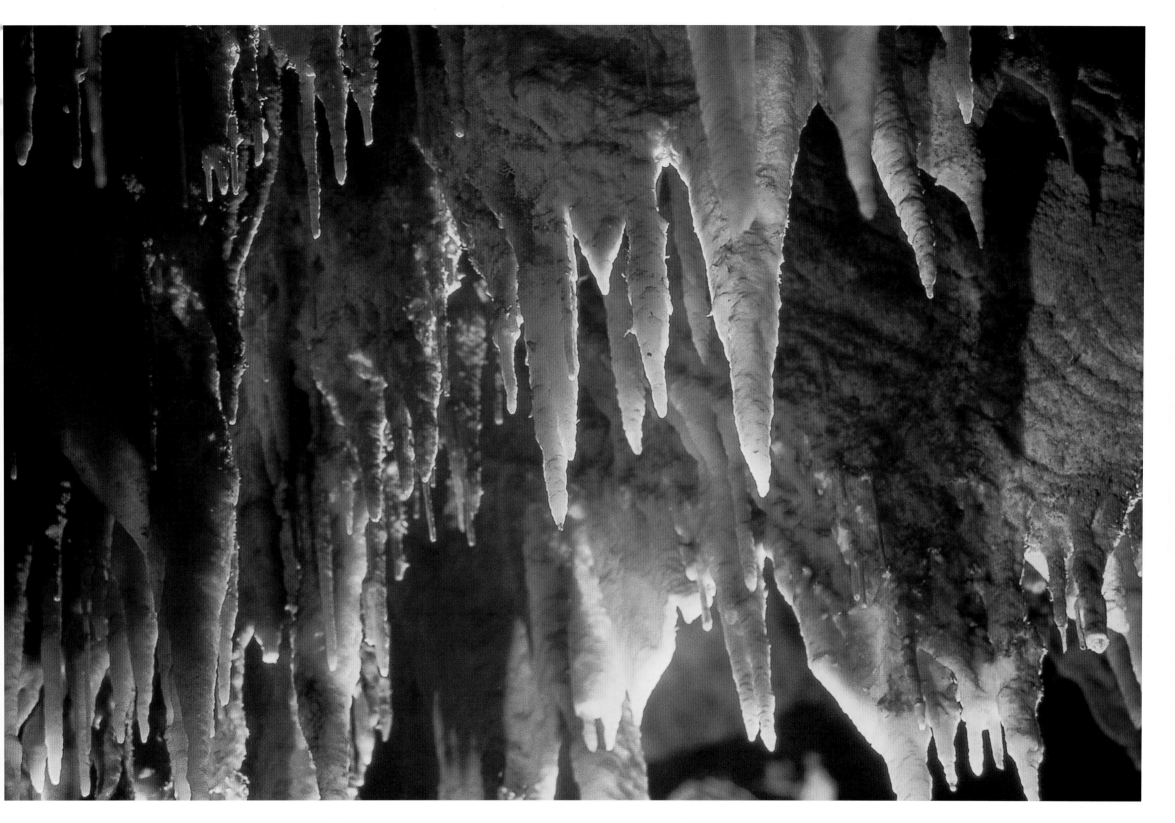

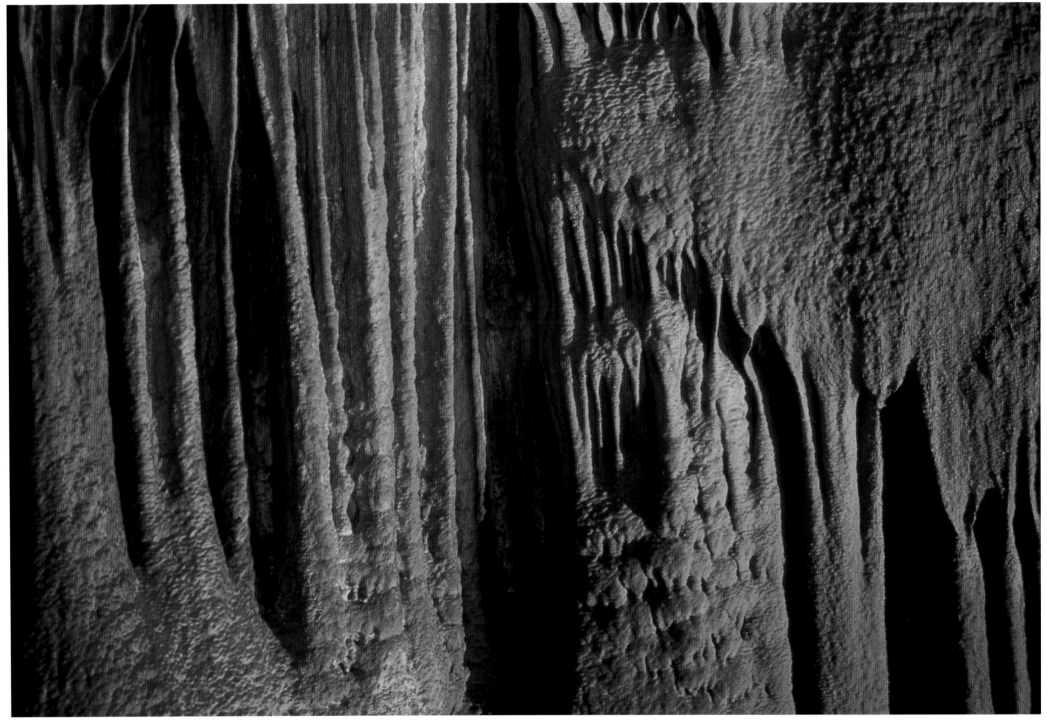

Detail of Frozen Niagara formation, Mammoth Cave

*Flowstone at
Frozen Niagara,
Mammoth Cave*

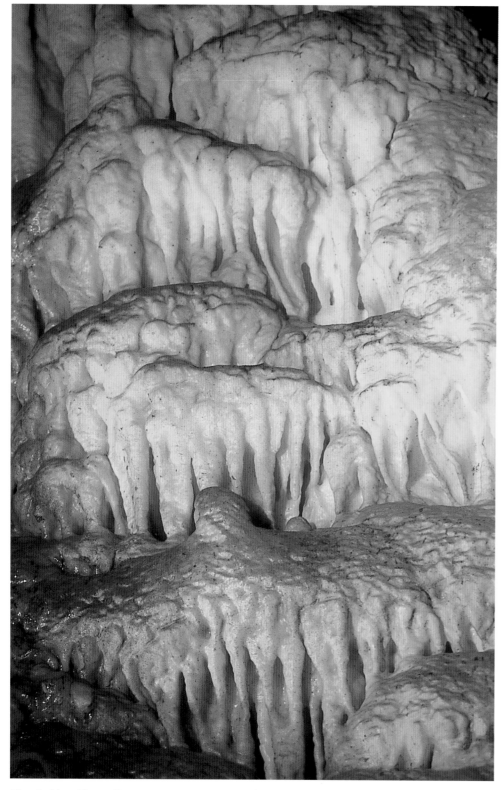

The Golden Fleece, Drapery Room, Mammoth Cave

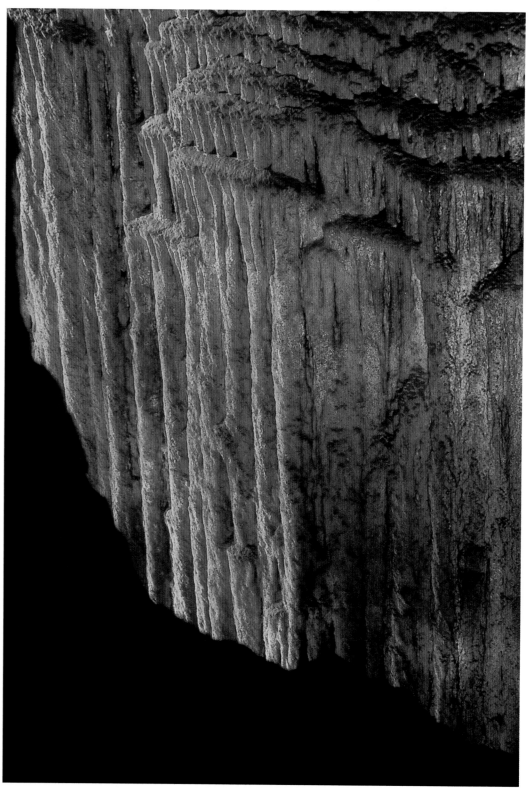

Frozen Niagara flowstone, Mammoth Cave

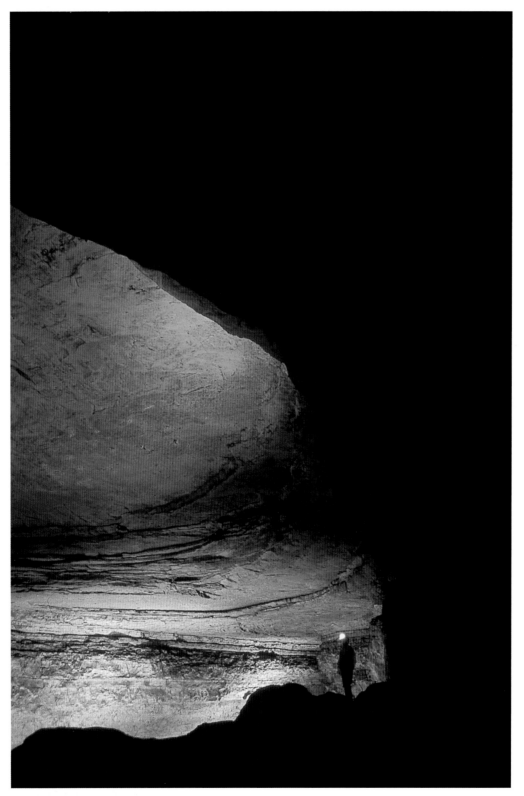

Rotunda Room, Mammoth Cave

Echo River Passage, Mammoth Cave

Audubon Avenue,
Mammoth Cave

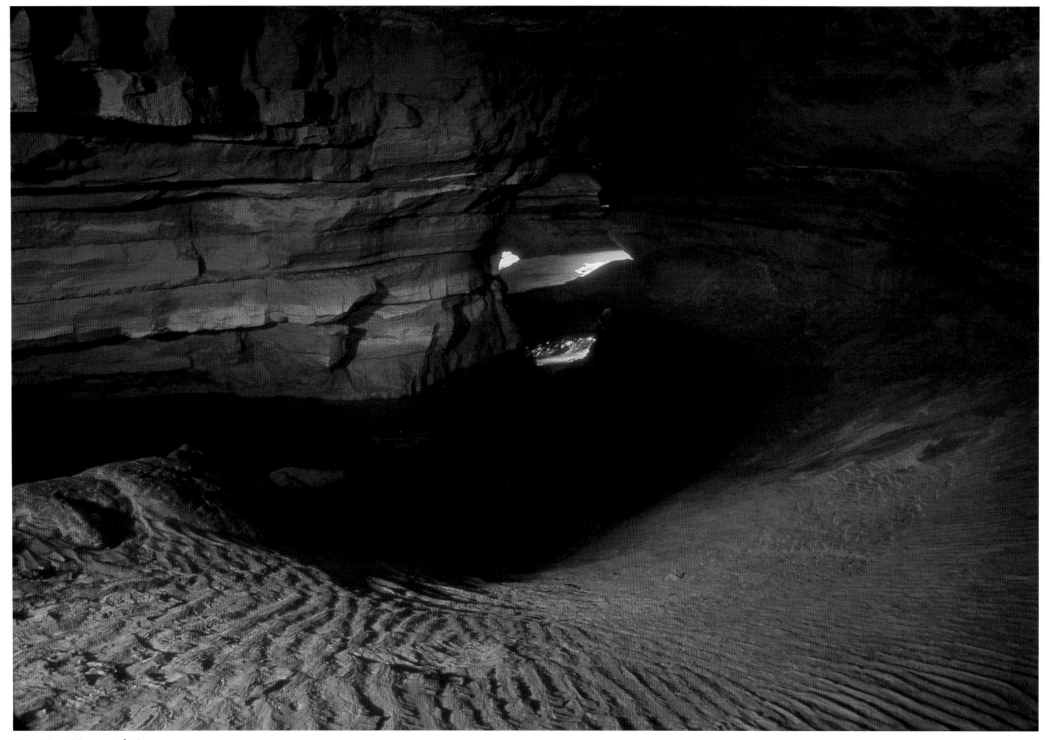

River Styx, Mammoth Cave

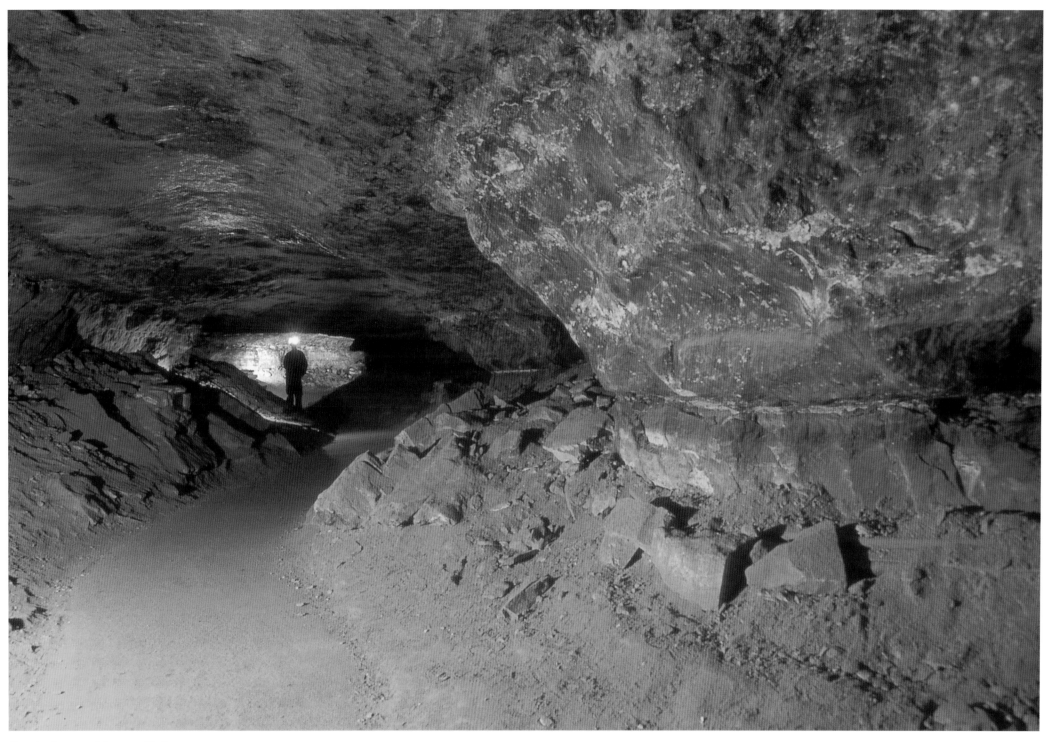

Sparks Avenue, Mammoth Cave

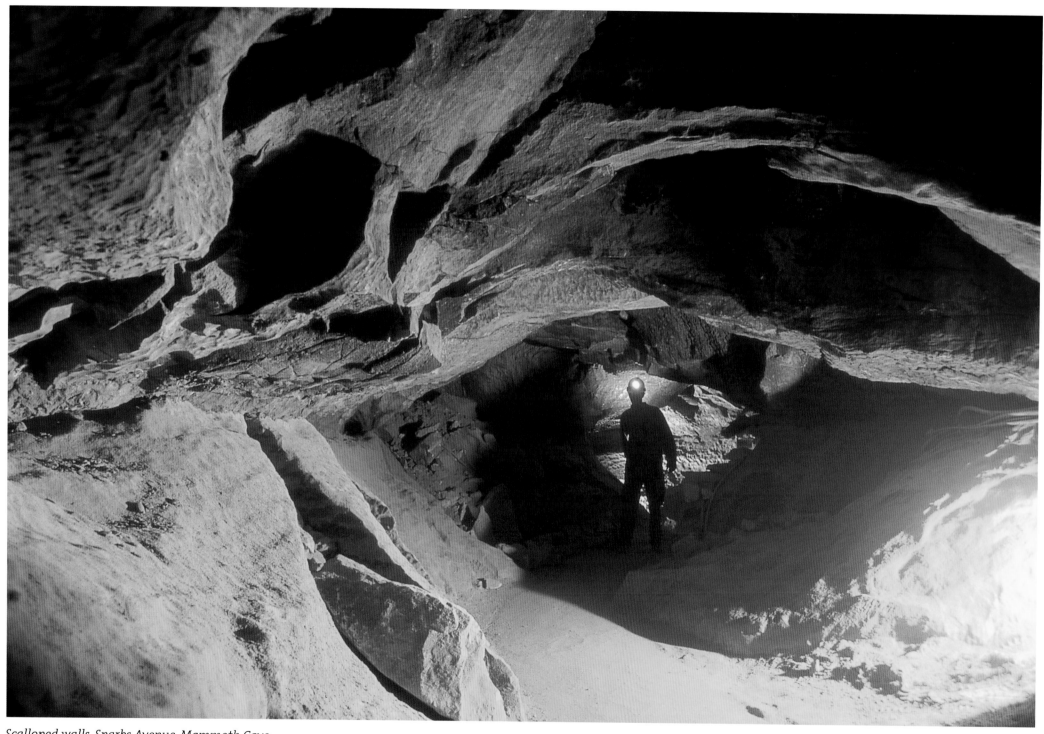

Scalloped walls, Sparks Avenue, Mammoth Cave

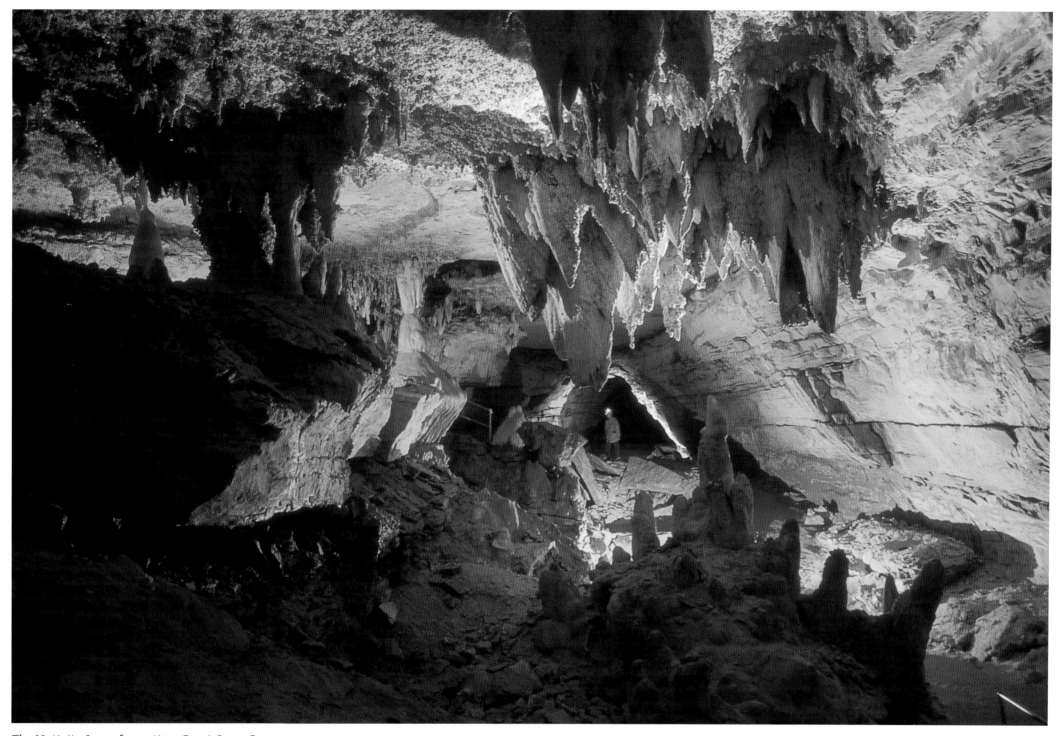

The Nativity Scene formation, Great Onyx Cave

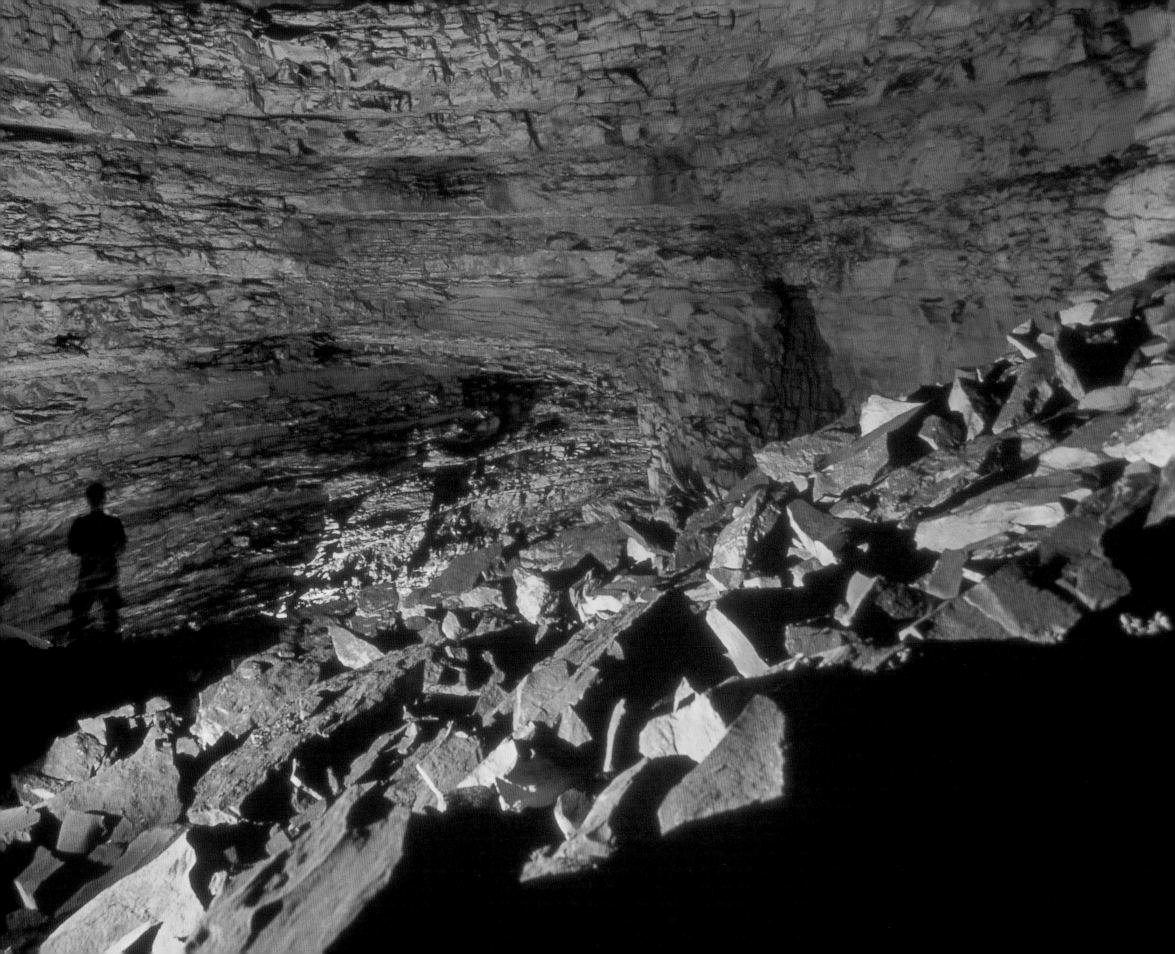

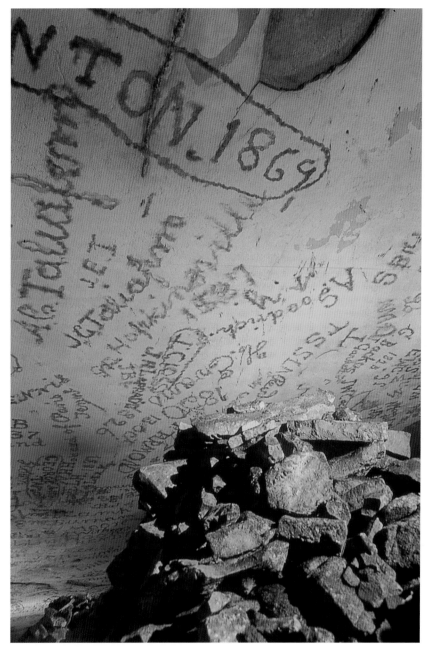

Smoke signatures, Gothic Avenue, Mammoth Cave

Elizabeth's Dome, Mammoth Cave

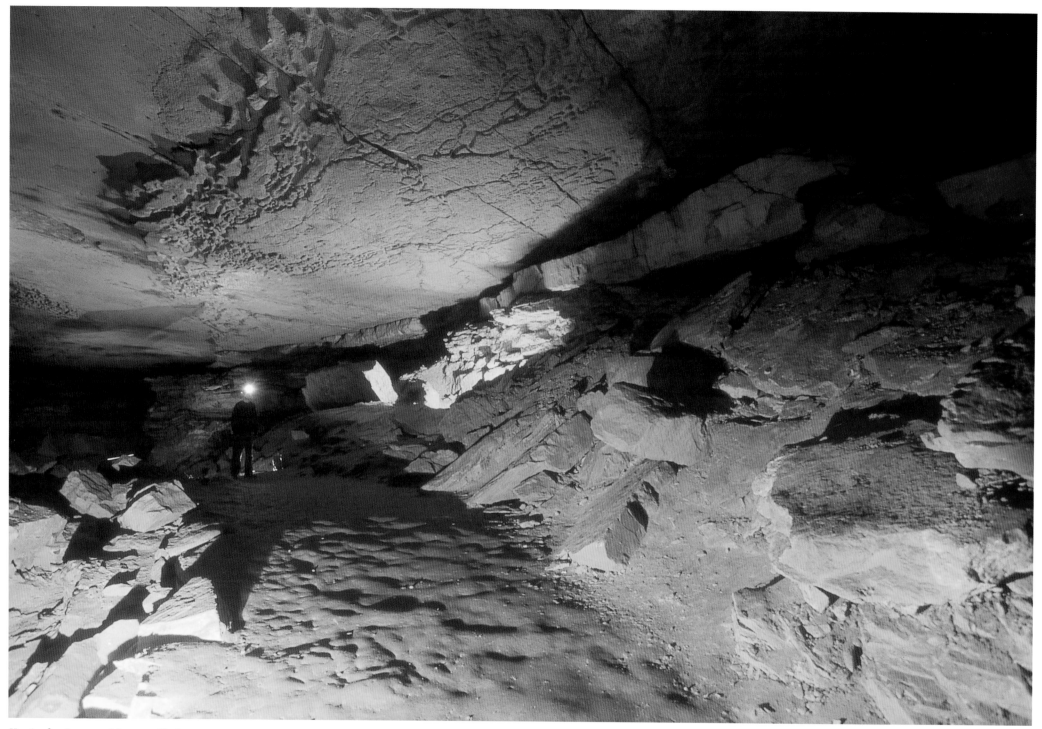

Kentucky Avenue, Mammoth Cave

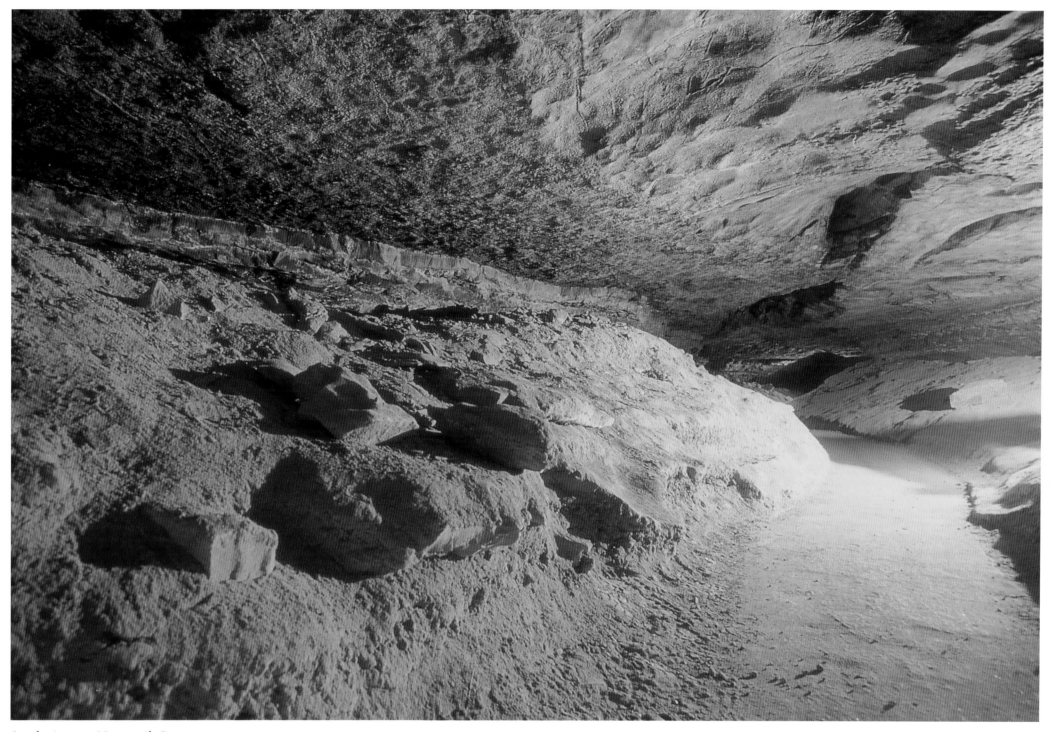

Sparks Avenue, Mammoth Cave

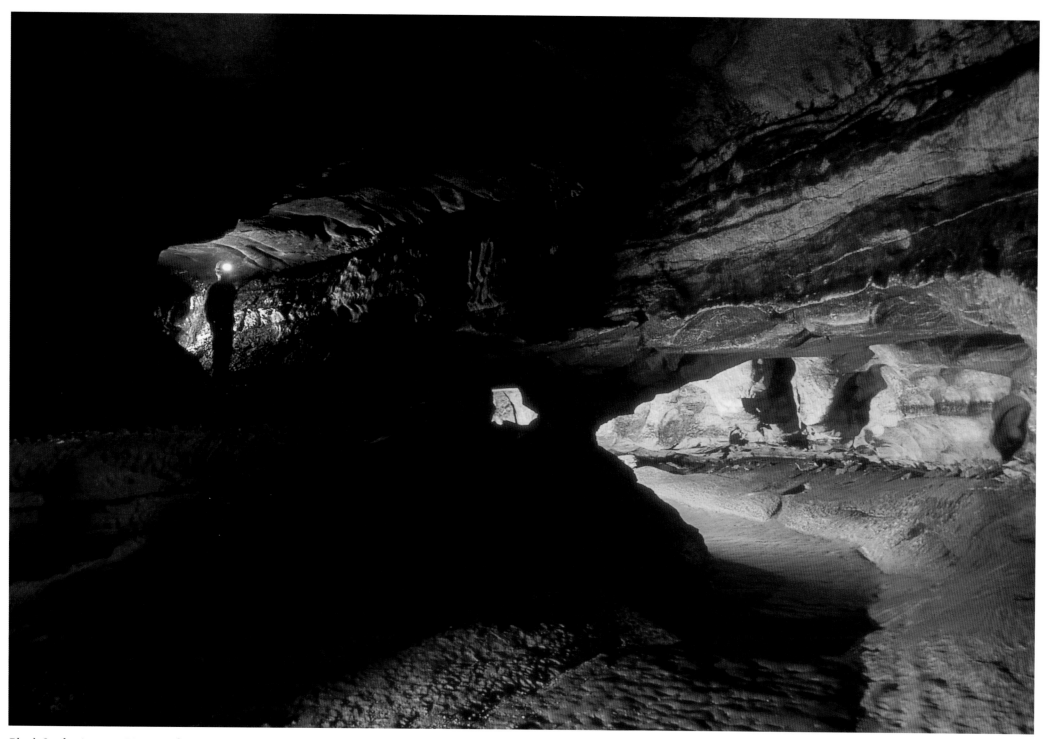

Black Snake Avenue, Mammoth Cave

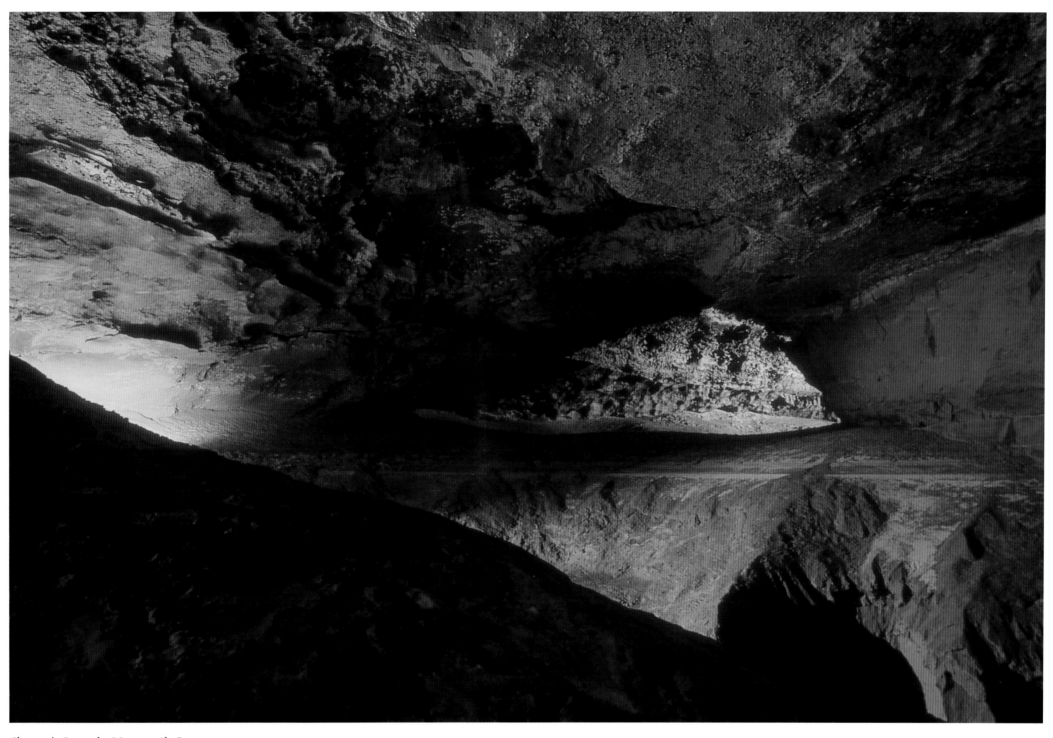

Sharon's Cascade, Mammoth Cave

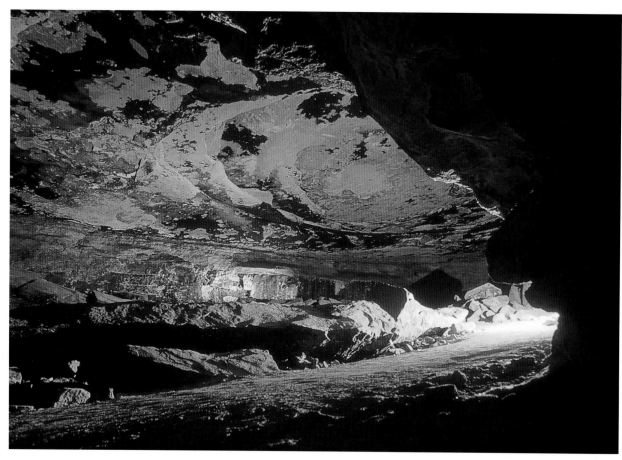

Wright's Rotunda, Mammoth Cave

Indian Avenue, Mammoth Cave

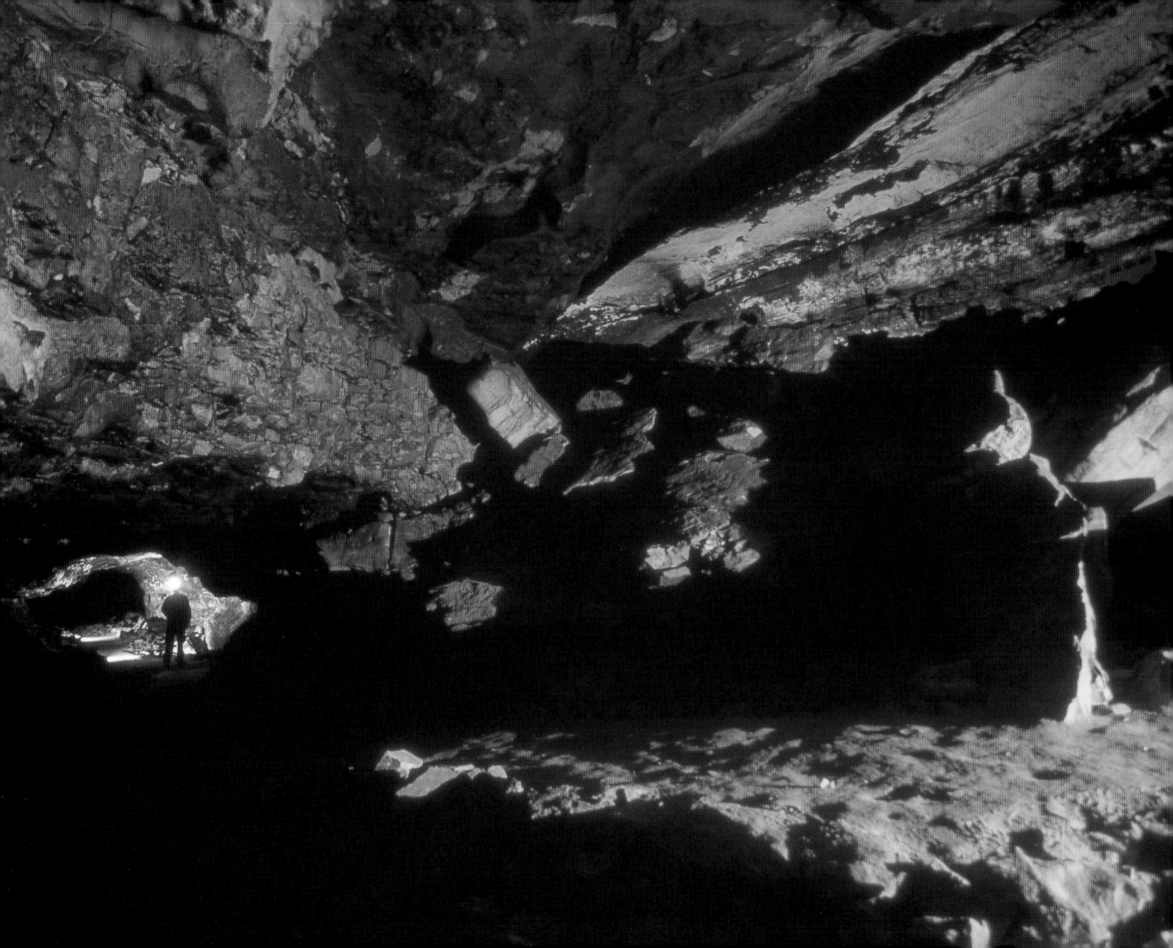

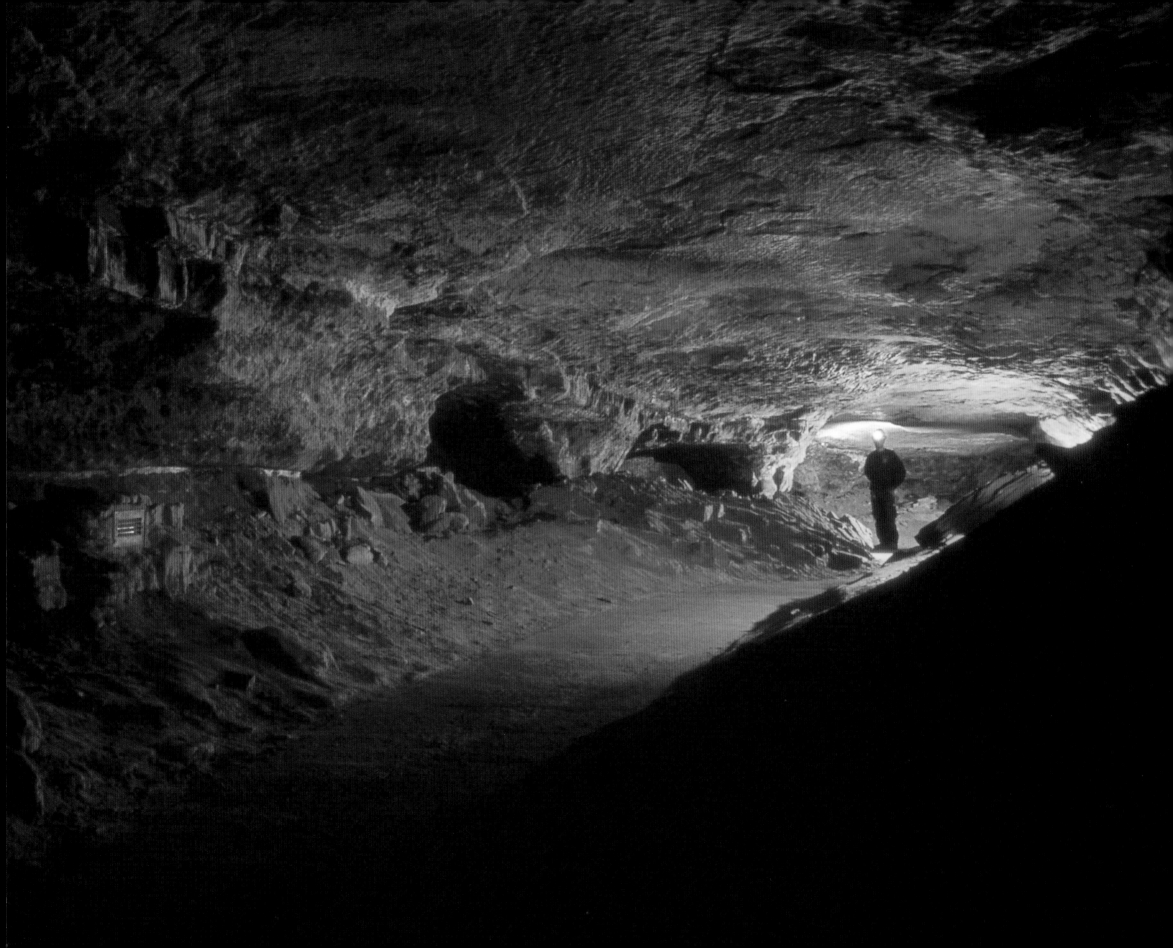

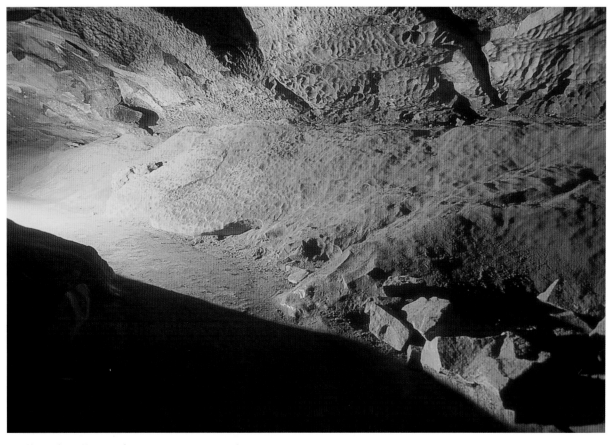

Scalloped walls, Sparks Avenue, Mammoth Cave

Sparks Avenue, Mammoth Cave

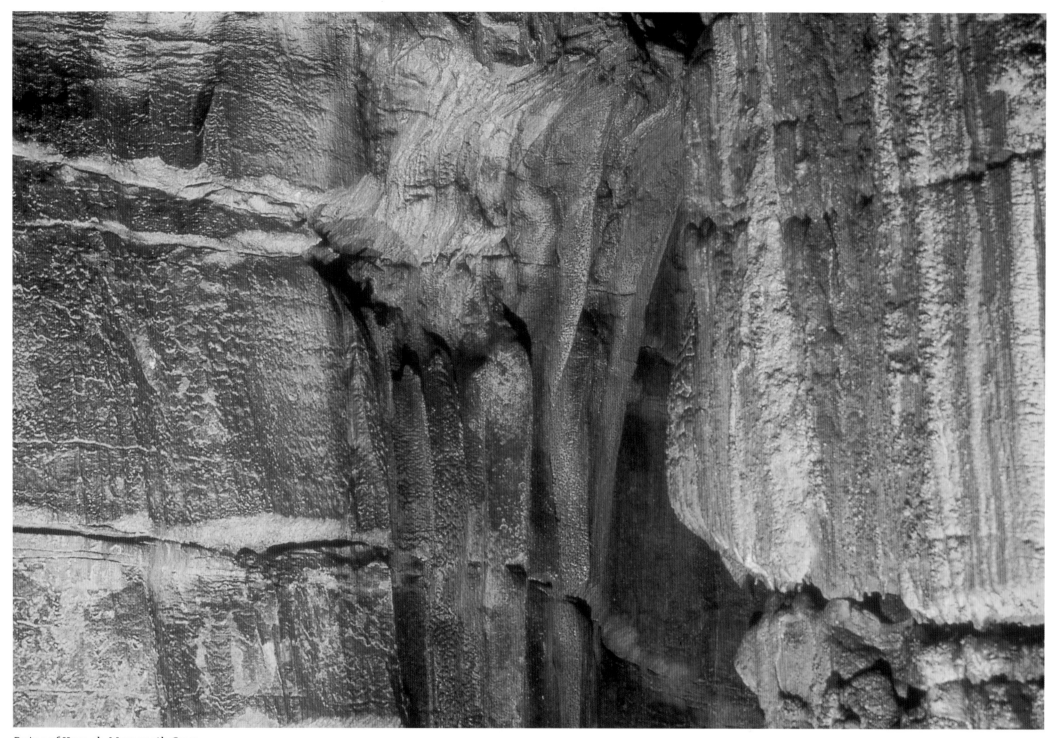

Ruins of Karnak, Mammoth Cave

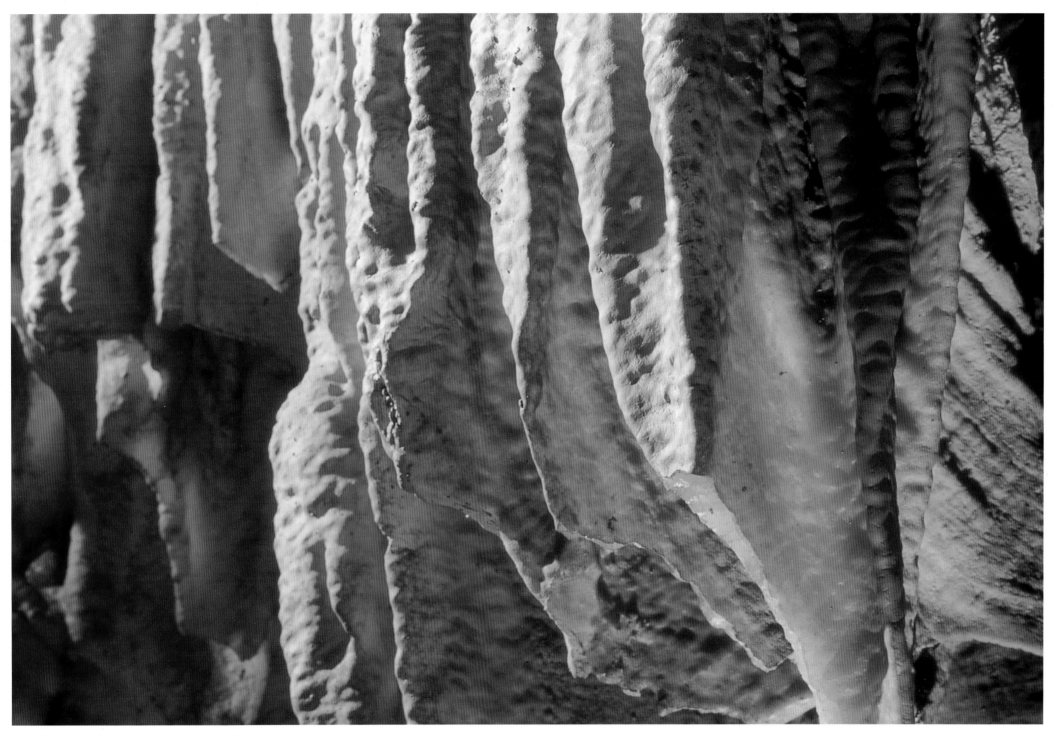

Semitranslucent formations at Frozen Niagara, Mammoth Cave

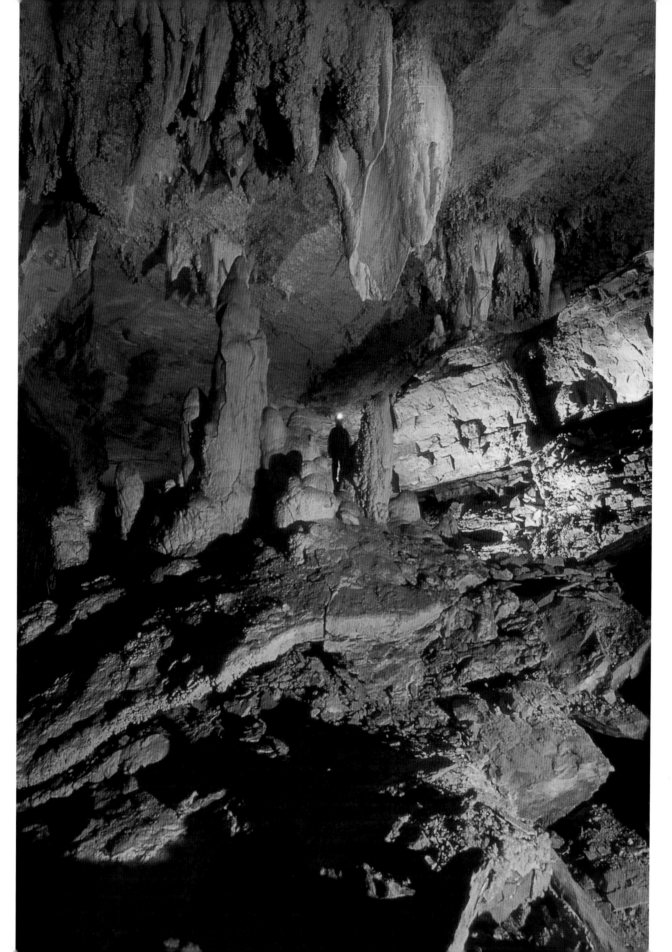

The Nativity Scene formation, Great Onyx Cave

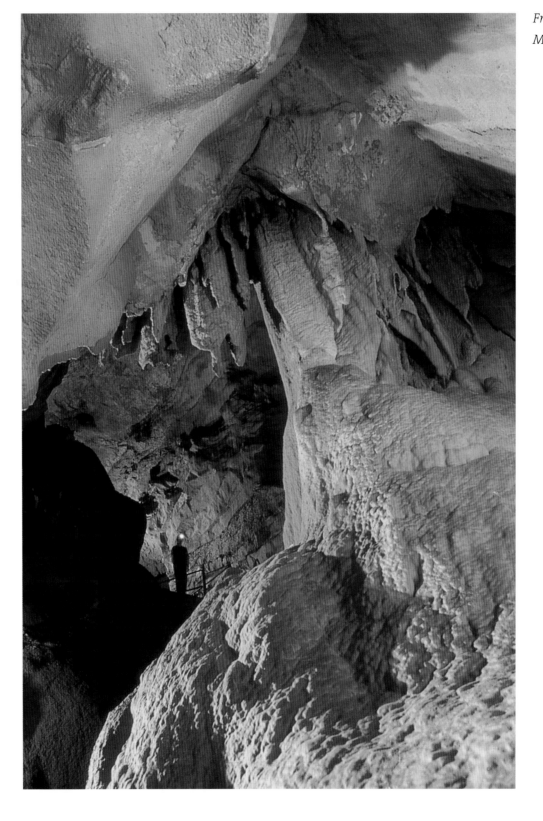

Frozen Niagara formation,
Mammoth Cave

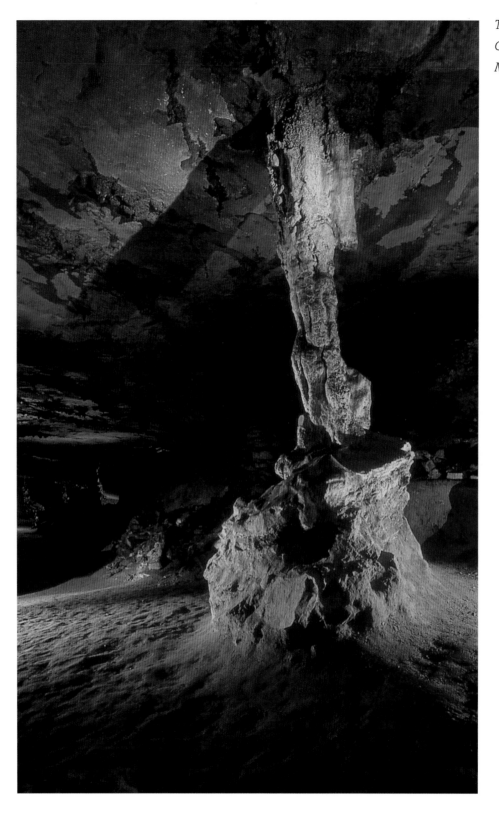

*The Oak Post,
Gothic Avenue,
Mammoth Cave*

*Light from inside
tuberculosis hut, Main Cave,
Mammoth Cave*

50

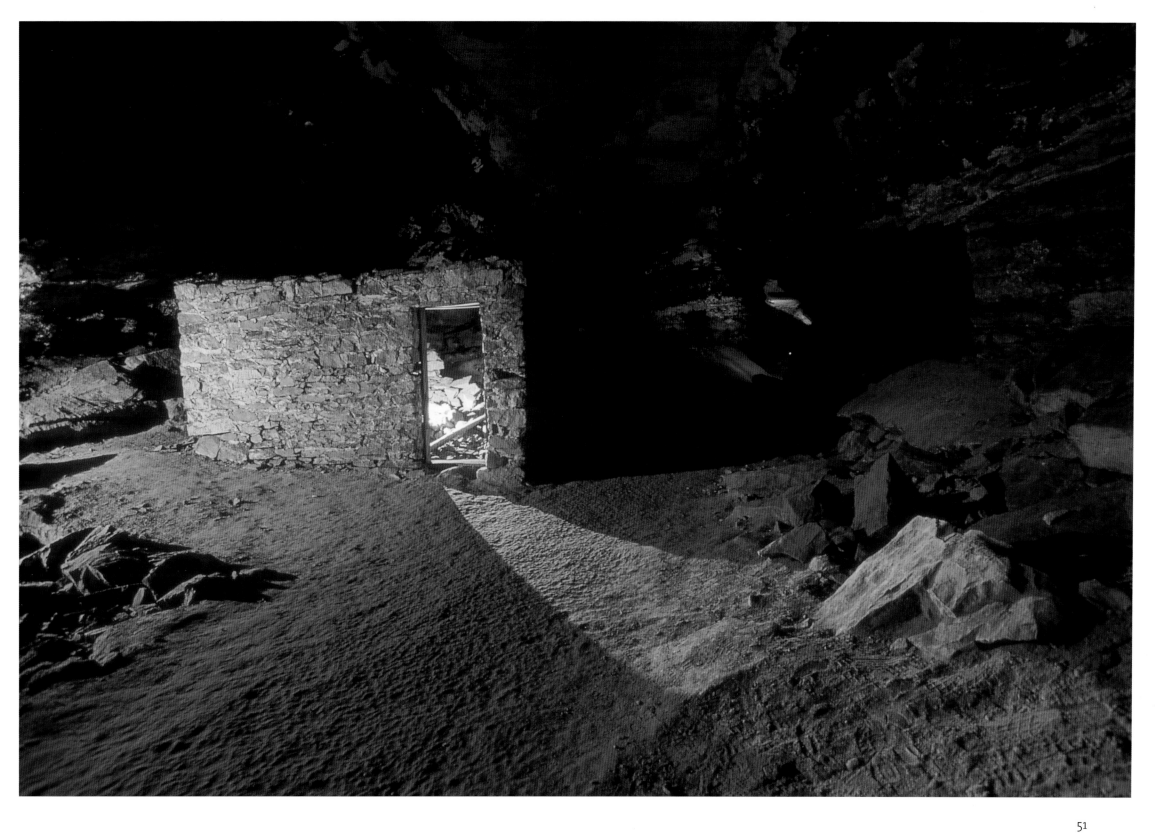

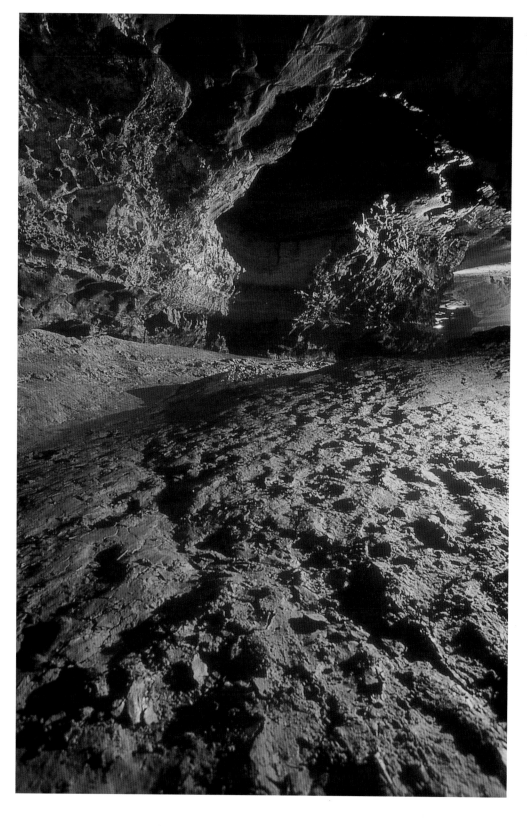

View toward the Dead Sea,
Mammoth Cave

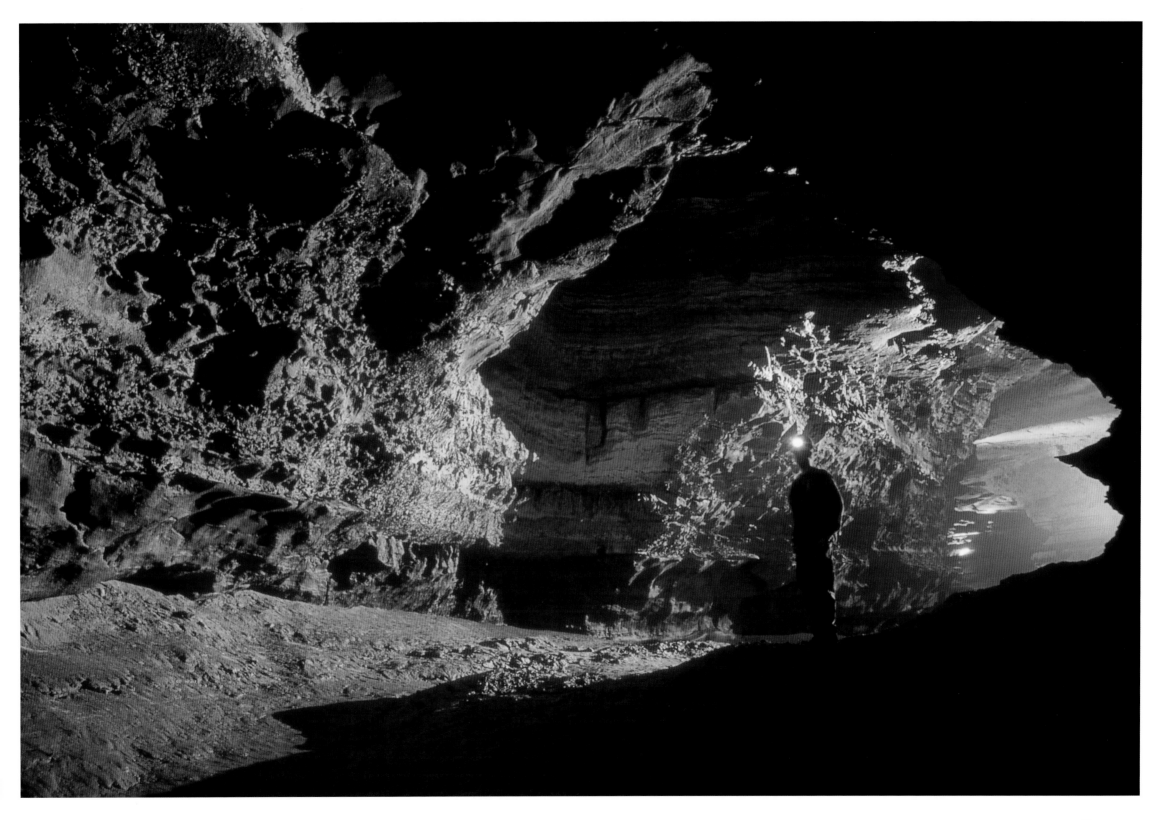

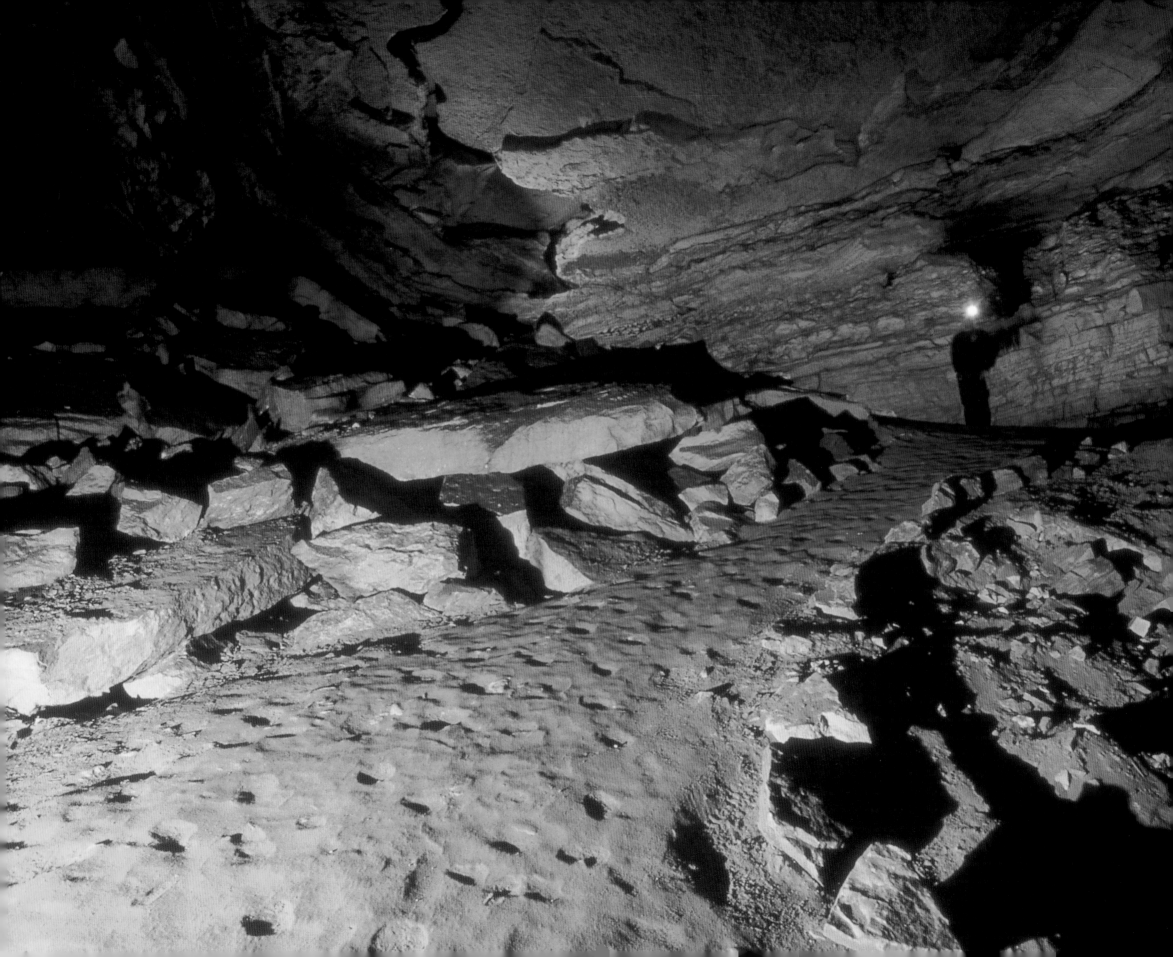

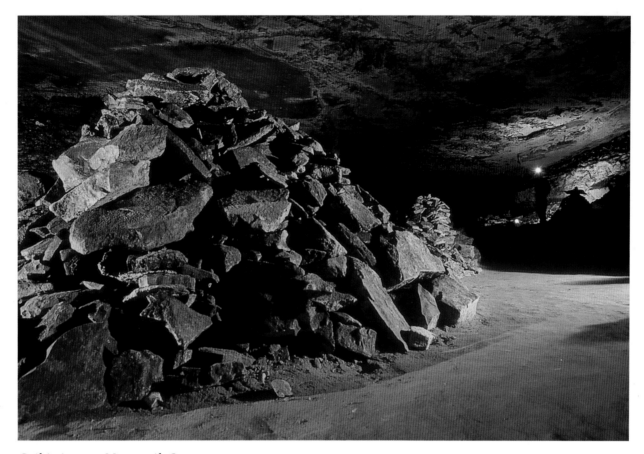

Gothic Avenue, Mammoth Cave

Kemper Hall, Mammoth Cave

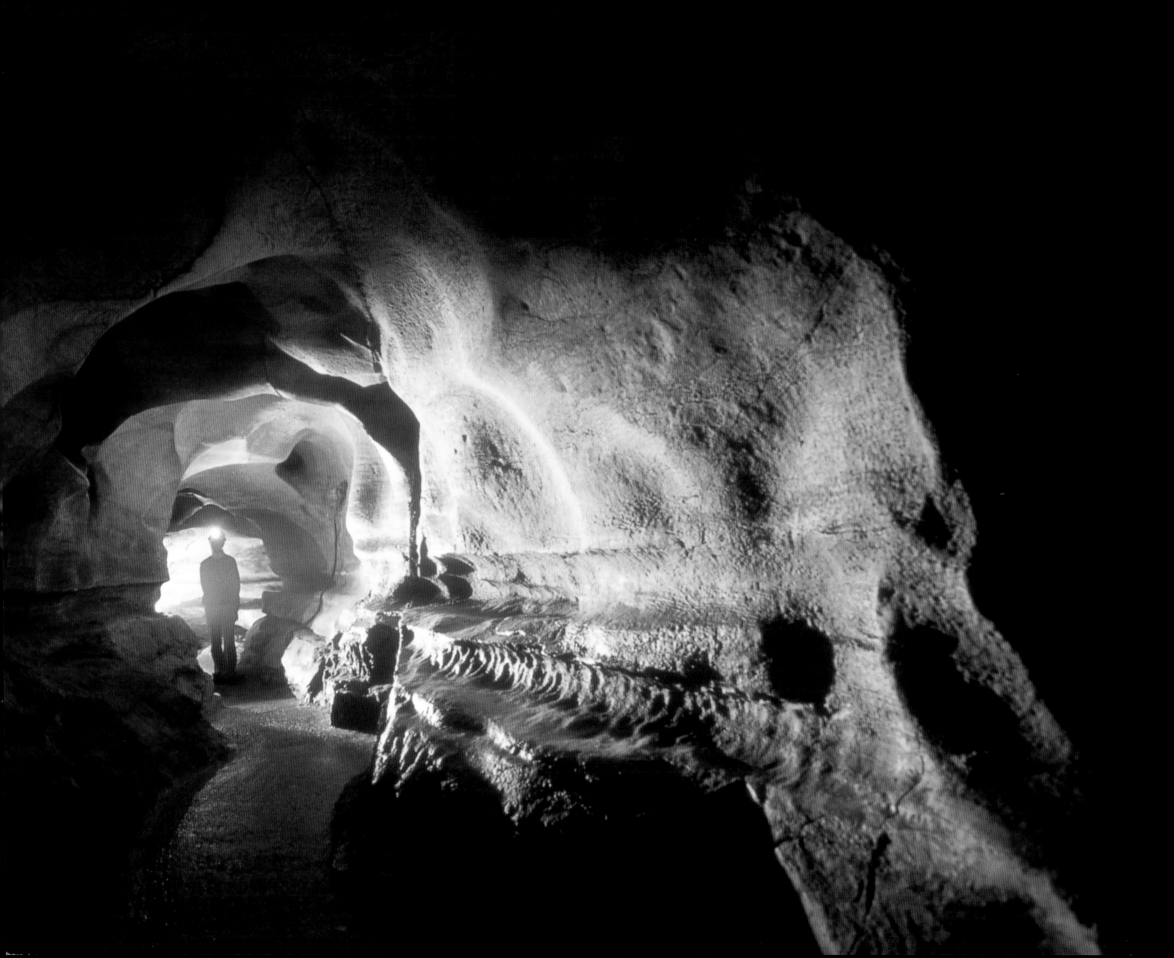

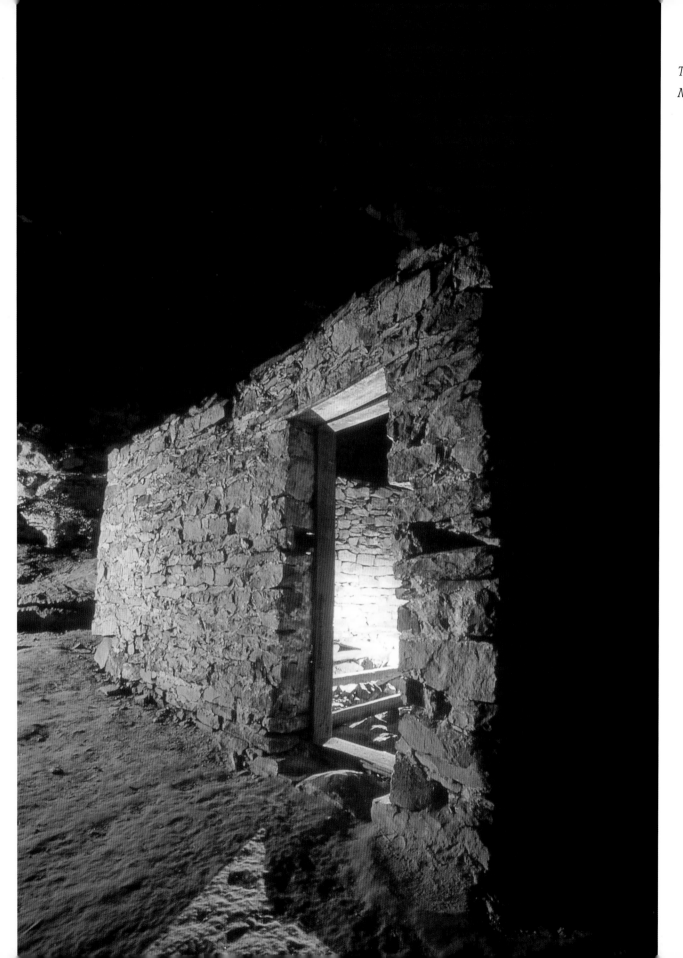

Tuberculosis hut, Main Cave,
Mammoth Cave

New York Subway,
Mammoth Cave

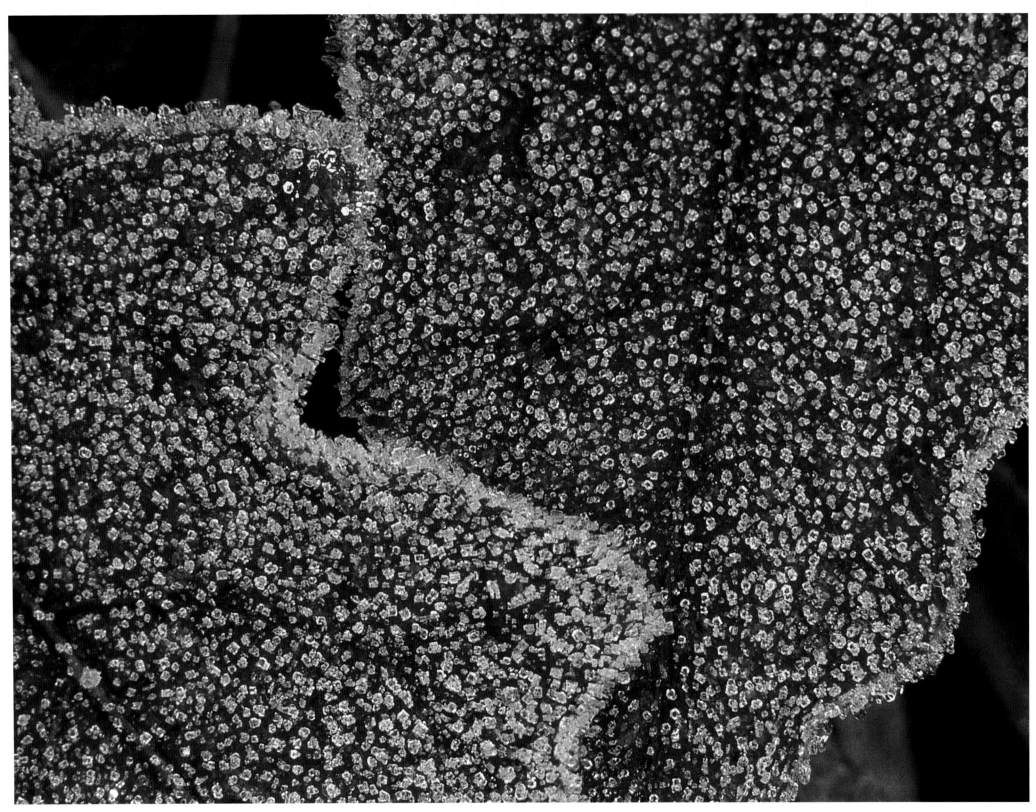

Detail of frost-covered leaf, Great Onyx Cave Road

Sitting Quietly

Leaves crackle under my boots as I pause at a bend in the trail, glance down at the map, and dig into my back pocket for a compass. Reassured of the direction I'm hiking, I move due south toward the bed of First Creek. It's late afternoon, and the low sun casts the long shadows of trees against the downward slope of the hill. I've heard rumors that up ahead are some of the most impressive cliffs in the park. Continuing down the hill, I reach a small stream, which I follow, hoping to find the cliffs. After following the creek for nearly an hour, the cliffs are still not visible. Late afternoon is becoming dusk, and the golden light behind the clouds casts a beautiful warm glow on the forest floor. Disappointed that I won't be able to continue, as the sun will set soon, I stop for a snack and a rest before turning around.

With no one else in sight, it seems that I am part of the woods around me. I listen carefully as the wind gently rustles the leaves and acorns plummet to the forest floor with a dull thud. Although I don't realize it at first, my attention has shifted. I've forgotten all about the cliffs I didn't get to see. The smallest details of the forest have taken over my thoughts. This woodland life is just as significant as the mighty river and the giant oaks that are the backcountry's most visible features. Although Mammoth Cave National Park contains many diverse geological features, the broad views begin to look similar after two months of hiking the trails. It is the smaller details, the things one can appreciate only by sitting quietly, that highlight the park's diversity. Concentrating on the vast but often overlooked areas aboveground, focusing on the smallest reverberation of life within the dense habitat of Mammoth Cave's forest, can be a rewarding and thrilling experience.

Sitting quietly provides a solid platform from which one can observe the surrounding world and discover the intricate fabric of nature. Attention to detail reveals the otherwise invisible.

The following dawn, as I slip and slide to the top of the slope alongside the mighty Green River, a crisp white light overtakes the golden hues of the reflected sunrise. A gentle wind weaves through the tall grasses. At first I see nothing, but I take my time, stopping every couple of feet, kneeling, and eventually the life of the forest comes into view. The gracefully swaying green and yellow grasses are filled with hundreds of tiny snails, each still covered in morning dew. Some are almost the size of a quarter, while others are barely the size of a pencil eraser. A glistening shell reflects a rainbow's worth of color as the sun begins to cut through the towering forest. I sit and watch the light enter

their world. Some of the snails are motionless, but others have begun their day, stretching out of their shells, warming up from the cool autumn night.

Each of these snails is an individual, yet all are reacting to the same stimuli—the sun, the morning dew, the gentle breeze. Of those that have not yet begun to rouse, some are perched on the petal ledges of tiny flowers. Others wisely choose the camouflage of a leaf's underside, but the majority stick to the thick stems of grass.

Looking closer at our surroundings can be an ideal way to observe the basic forces of nature at work. Patterns develop as water erodes rock; the elements split a giant tree, giving way to a small sprout; moist tree bark provides an ideal home for moss and fungus. By observing these forces on a small scale, it is easy to see how patterns form, and what at first appears to be a group effort is simply the same forces working on a multitude of subjects.

It is eye-opening when one realizes that despite the broad forces of nature at work throughout Mammoth Cave National Park, small differences exist everywhere. Seeing with a new perspective is the true aim of sitting quietly—to recognize what makes one particular slice of nature distinct and special. The world around us has achieved a sort of order despite the diversity, and after sitting quietly, it is evident that without these subtle differences there would be no harmony.

Mammoth Cave National Park is more than a cave, more than an impressive forest; it has more to offer than any individual will ever be able to experience. But slowing down and taking our time allows us to observe more of the world around us.

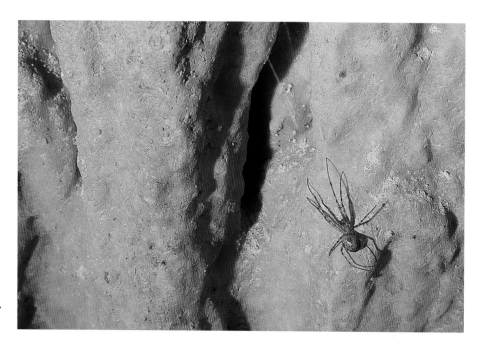

Orb-weaving spider on Frozen Niagara flowstone, Mammoth Cave

Snail, Mammoth Dome Sink Trail

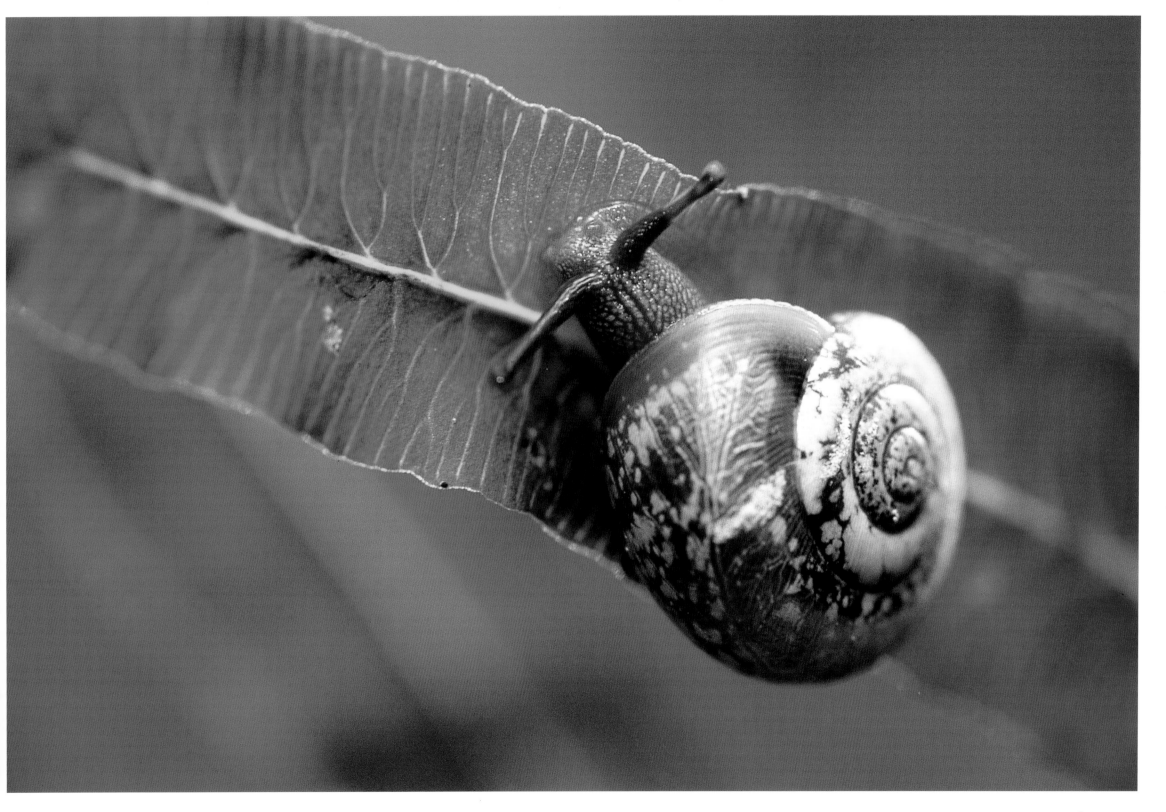

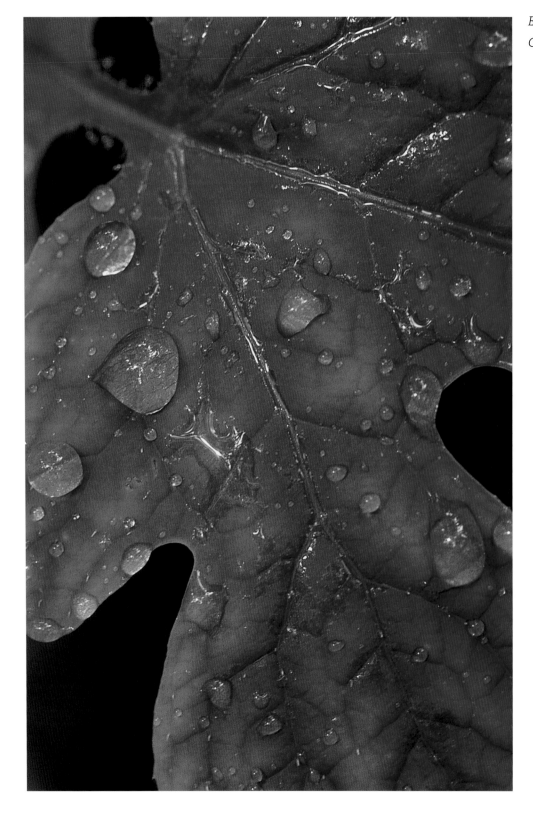

Early morning dew,
Green River Ferry Road

Sprout from fallen timber,
White Oak Trail

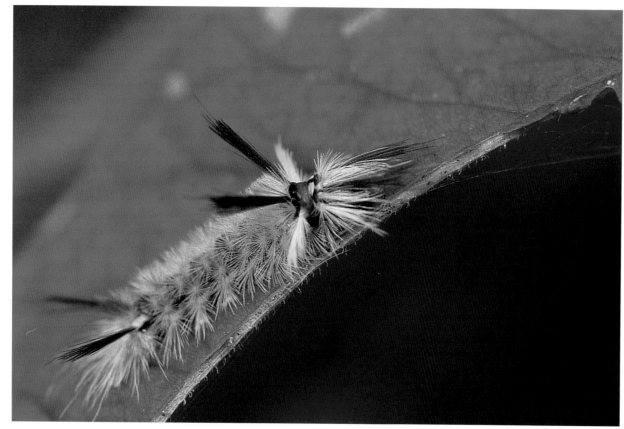

Tussock moth caterpillar, Cedar Sink Trail

Forest floor detail, White Oak Trail

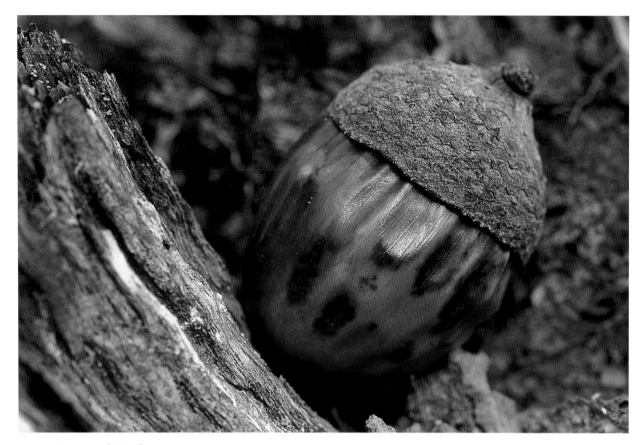

Acorn, First Creek Trail

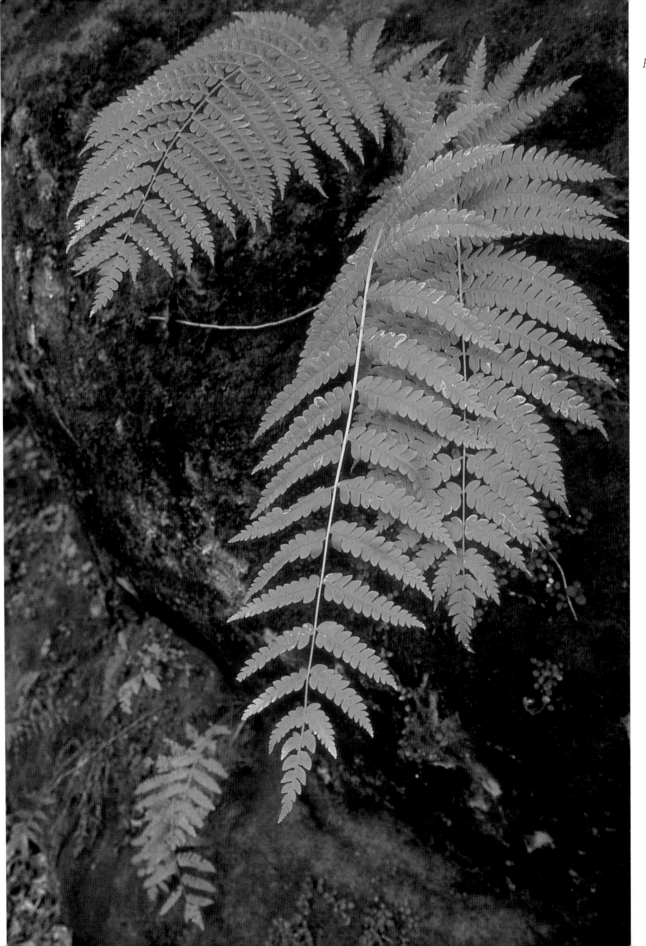

Ferns, First Creek riverbed

Virginia pine needles,
Wet Prong of Buffalo Loop Trail

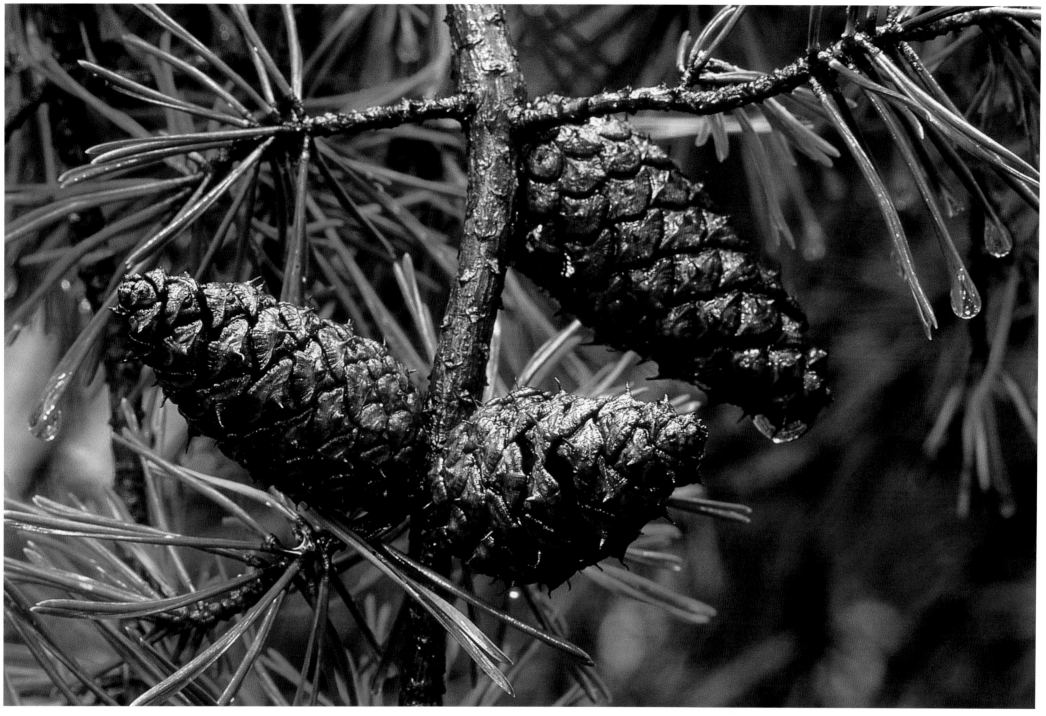

Virginia pine tree with pinecones, Wet Prong of Buffalo Loop Trail

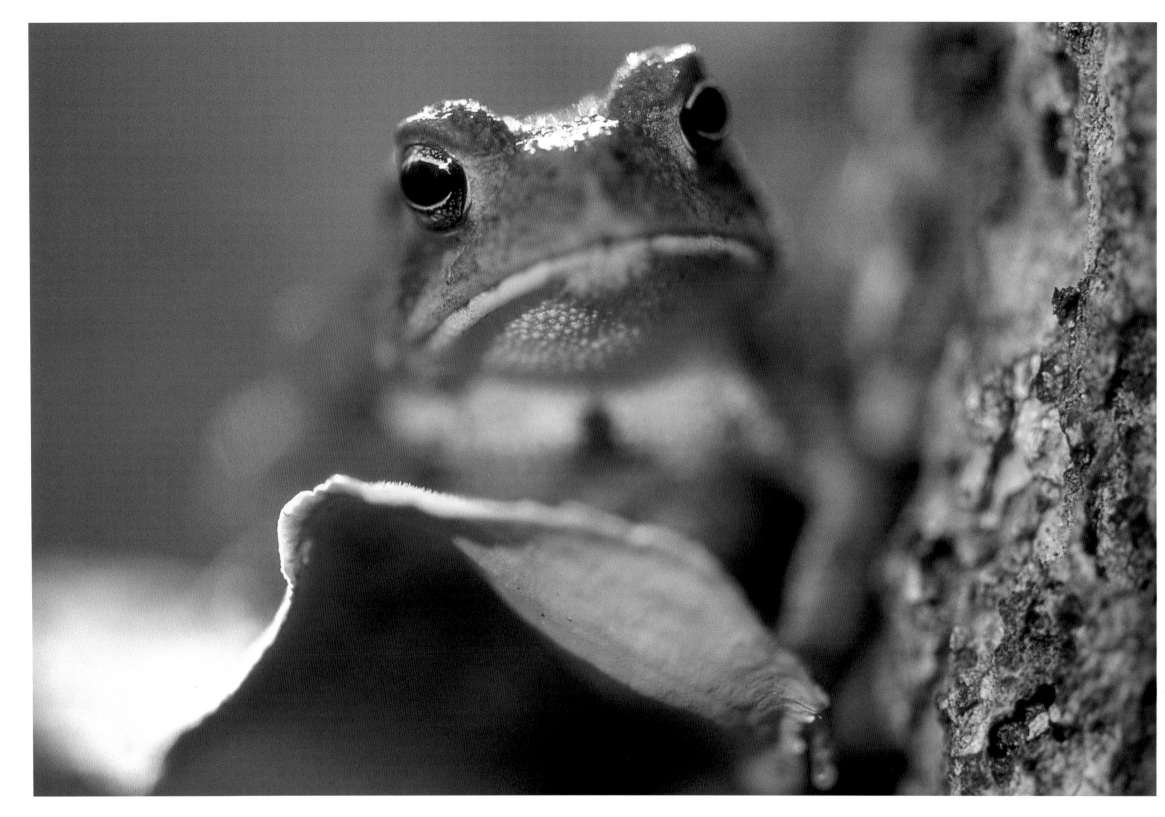

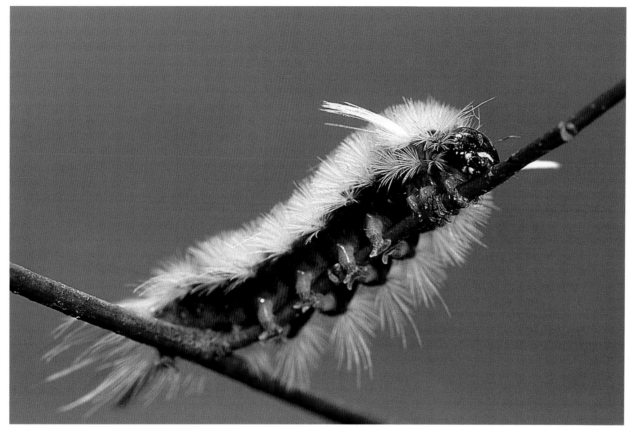

Tussock moth caterpillar, McCoy Hollow Trail

Toad on bracket fungi, First Creek Trail

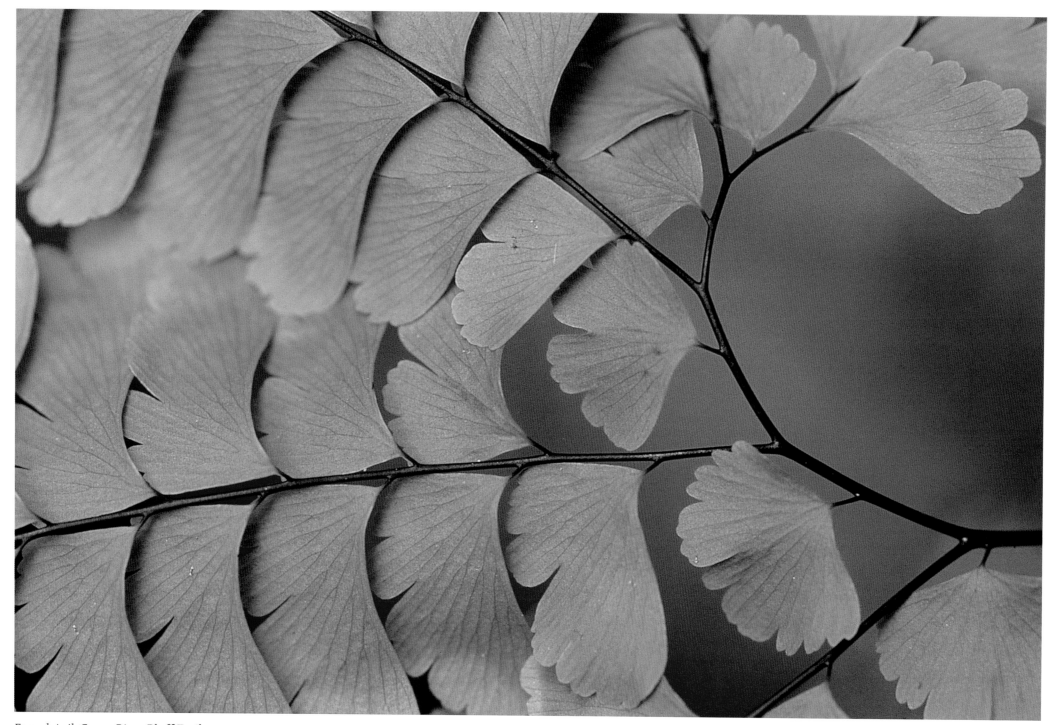

Fern detail, Green River Bluff Trail

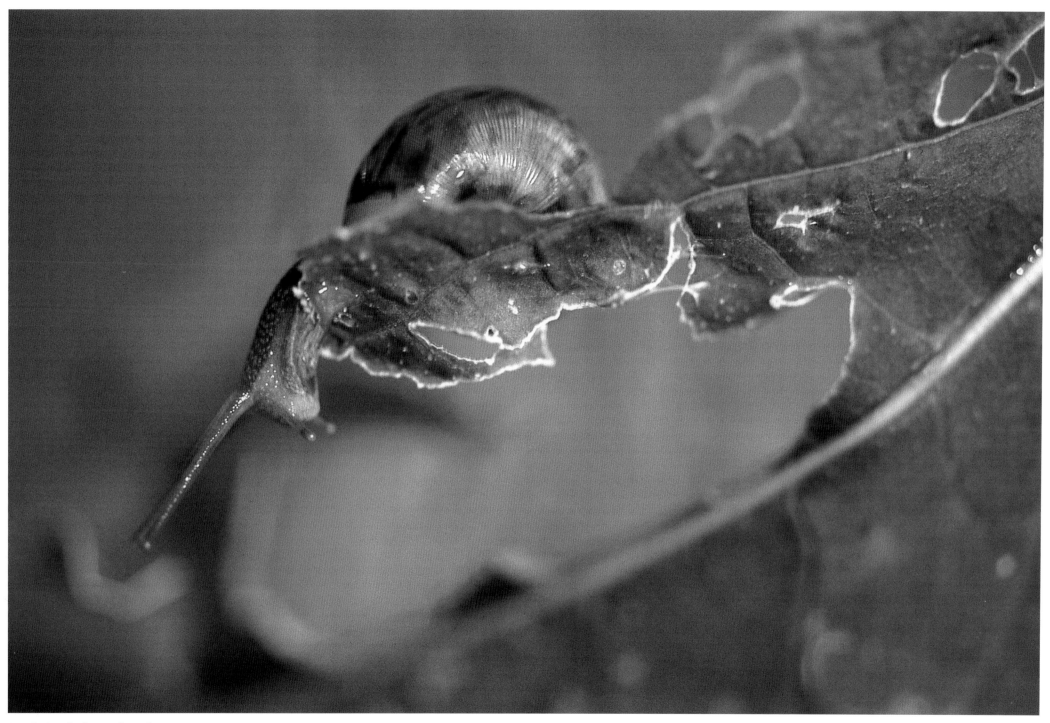

Snail, Turnhole Bend Trail

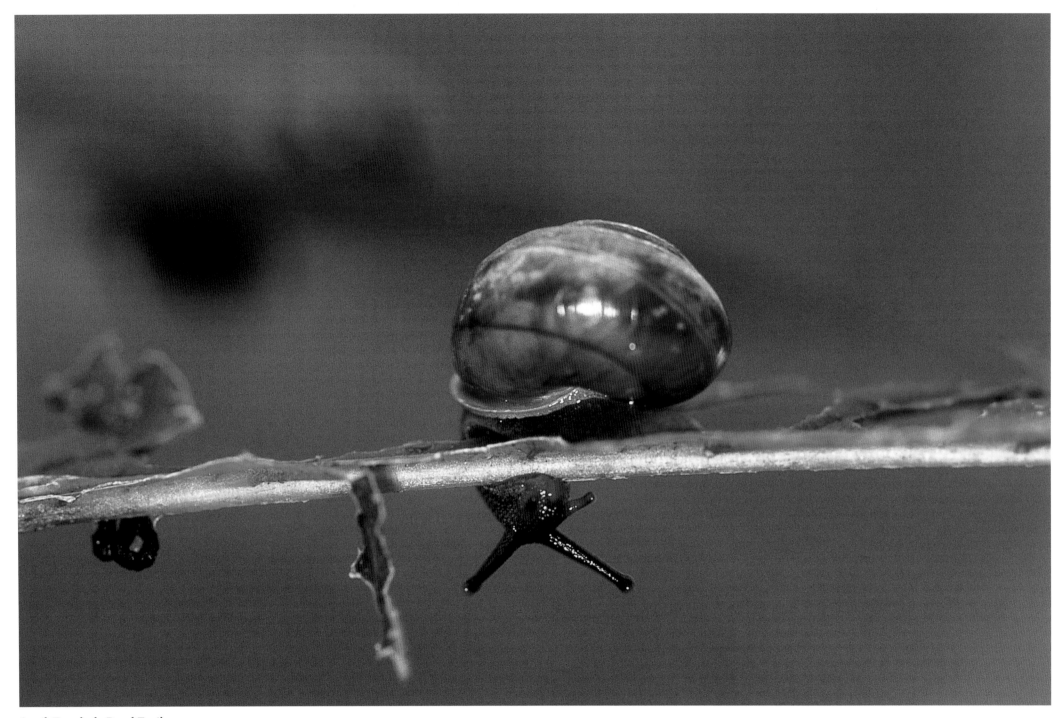

Snail, Turnhole Bend Trail

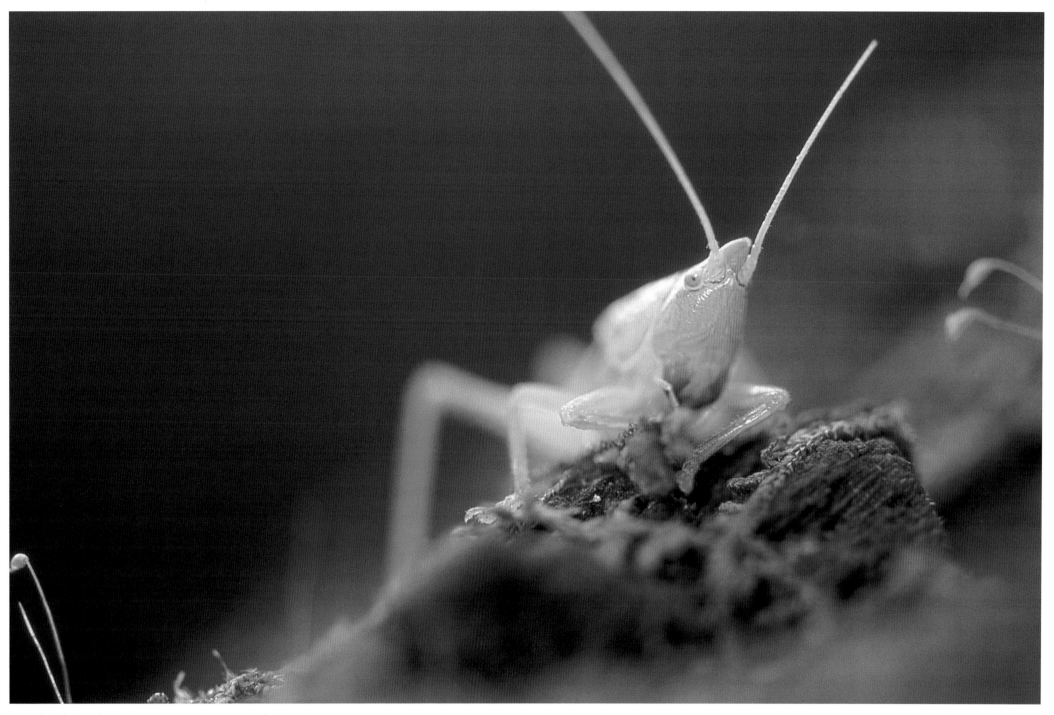

Conehead grasshopper, Great Onyx Cave Road

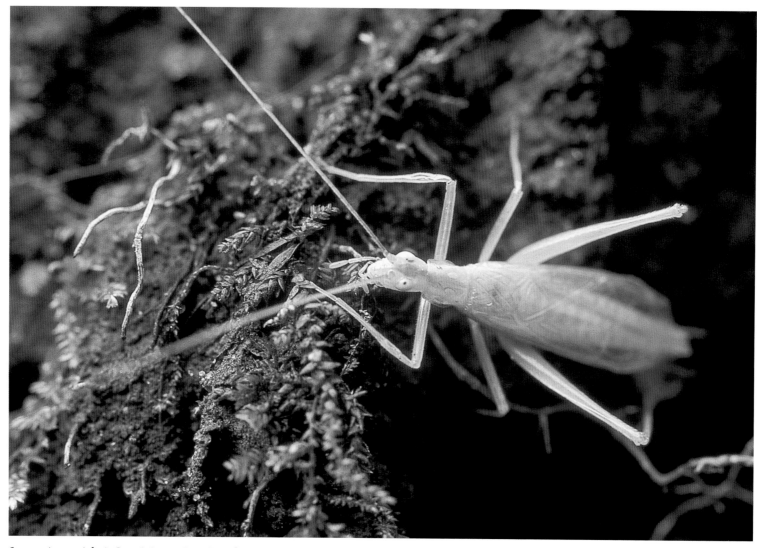

Snowy tree cricket, Great Onyx Cave Road

Southern leopard
frog atop common
earth-ball fungus,
Great Onyx Cave Road

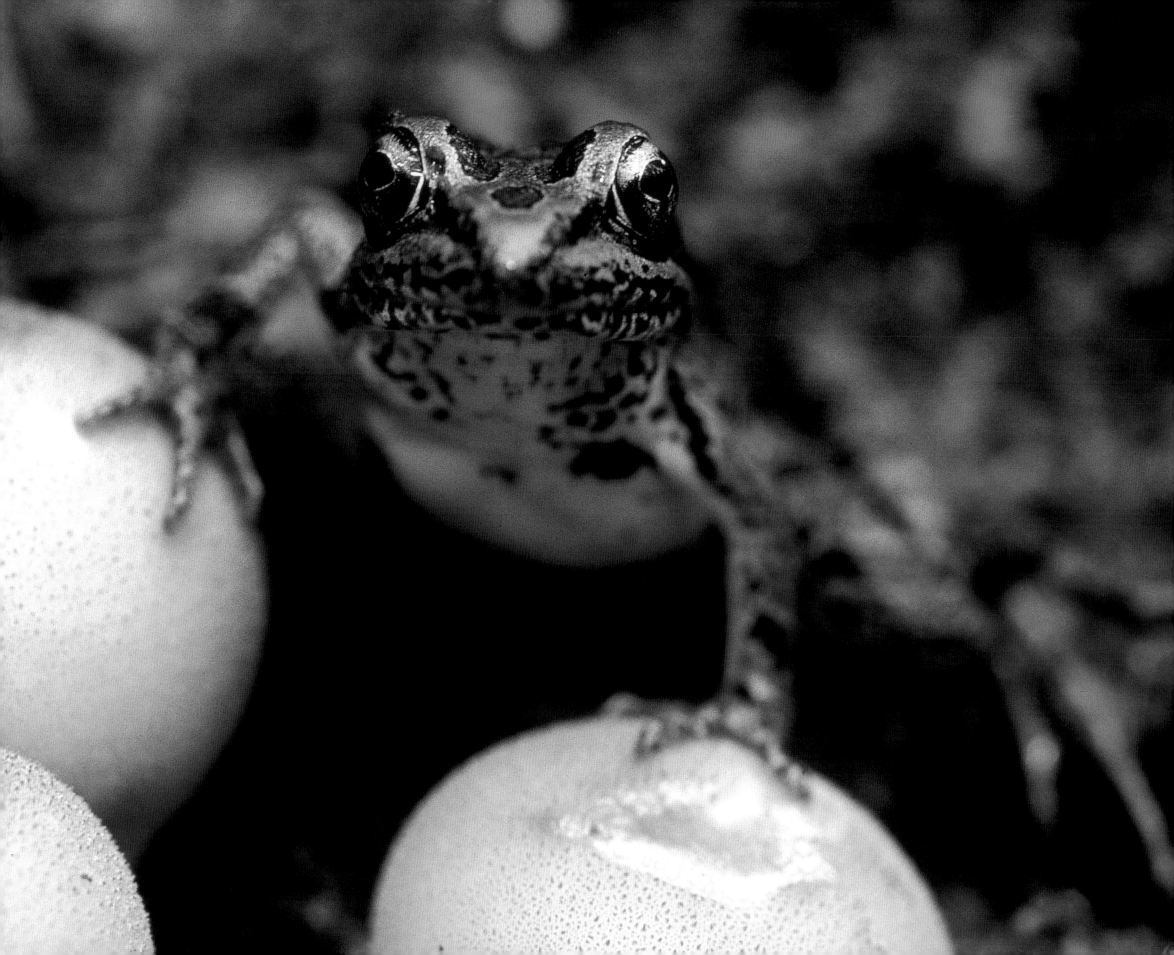

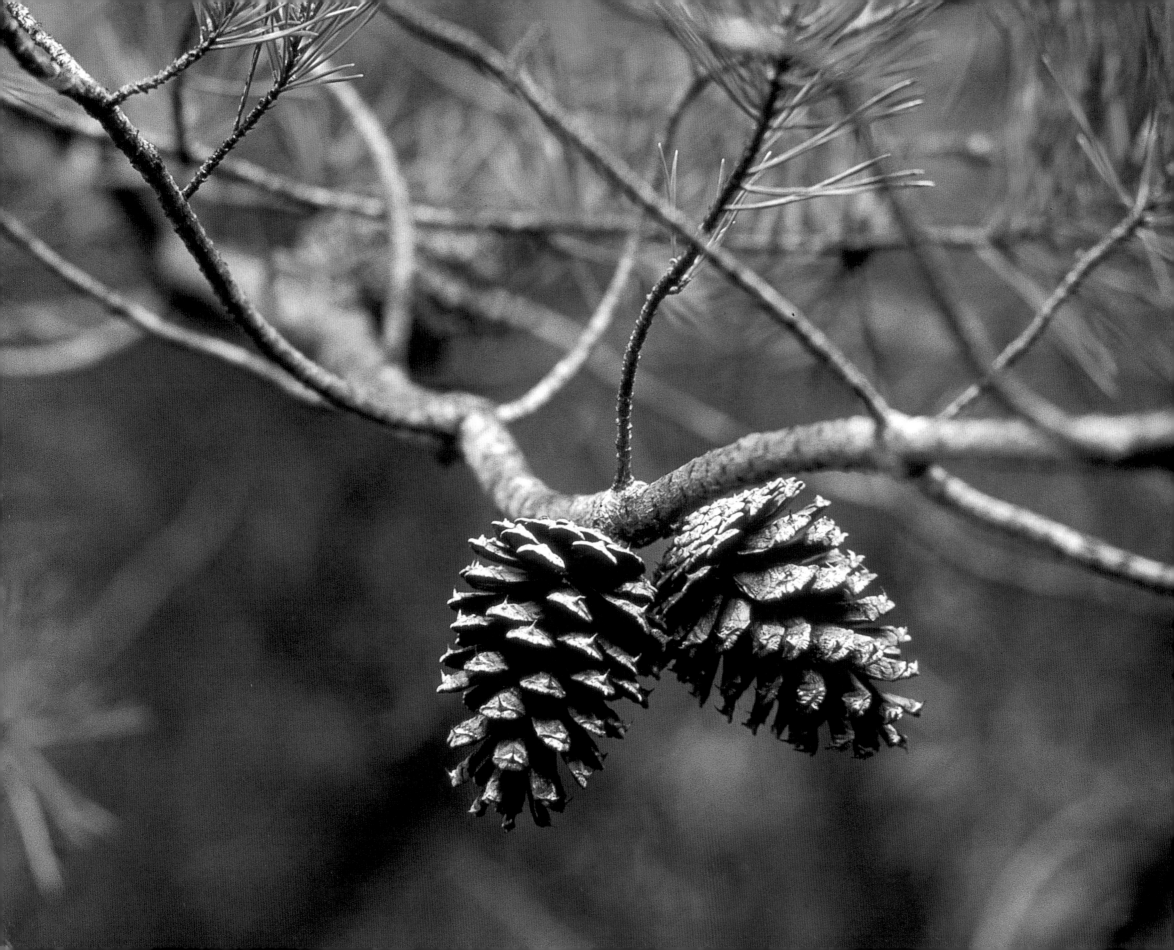

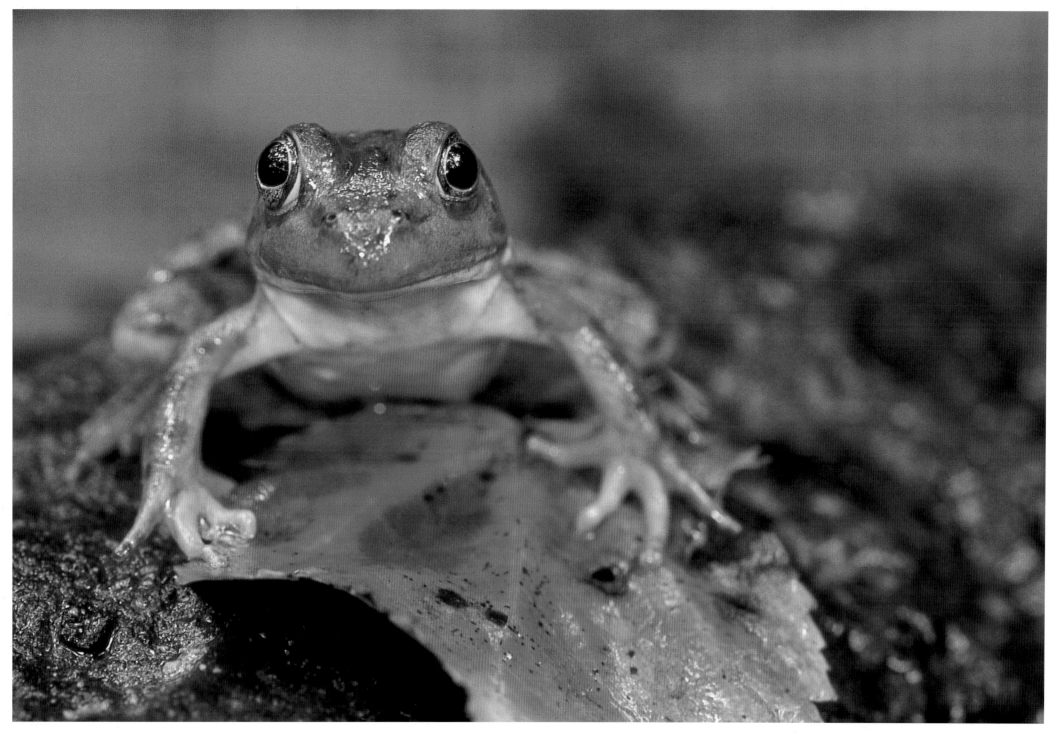

Green frog along the Buffalo Creek bank, Wet Prong of Buffalo Loop Trail

Virginia pine tree with pinecones, Great Onyx Cave Road

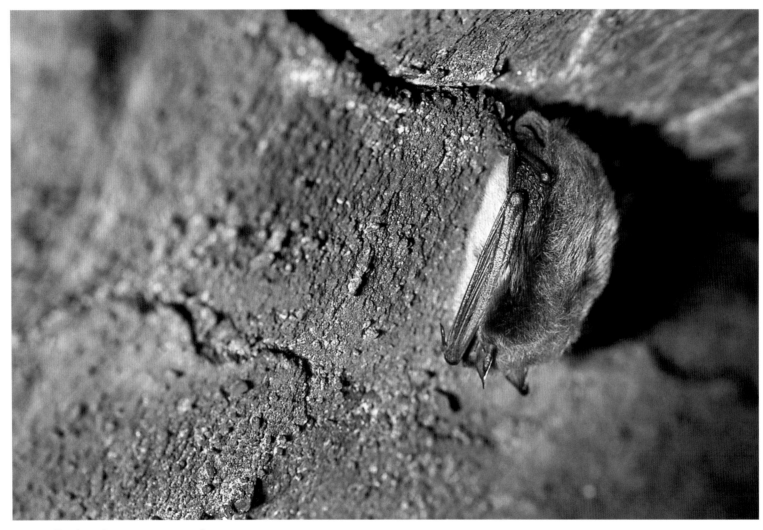

Pipistrellus bat sleeping, Mammoth Cave

Pipistrellus bat sleeping,
Mammoth Cave

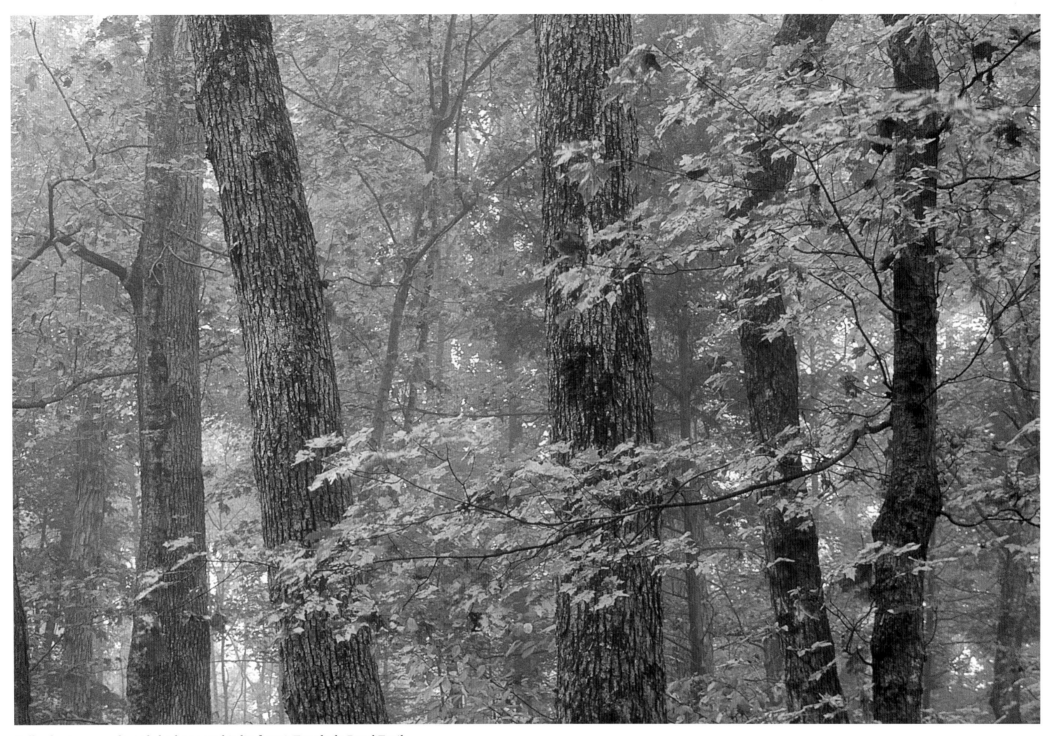

Fall color in a maple, oak, hickory, and tulip forest, Turnhole Bend Trail

The Whole of the Forest

Mellow rain pelts the orange canvas tent and fills the air as the predawn glow silhouettes the tall oaks above. The stars begin to fade; morning will be here soon. A cool, crisp autumn breeze whisks through the tent, bringing with it the sweet aroma of the forest. A woodpecker searches for a morning meal with a sudden thumping as loud as a jackhammer.

As I descend the mud-encrusted bank of the Green River, reflections dance and the sun inches toward the horizon. Oaks and sycamores tower over the opposite bank, their leaves gently floating through the air, creating ripples as they land and begin their journey downriver. Fish jump, and turtles scamper off a log. Across the river, a fawn awkwardly bends down for a sip of the cool, clear water. Submerged logs create rolling ripples in the water, catching leaves that have fallen far upstream, and provide an ideal perch for a noble white heron.

Water from the recent rain trickles down the muddy slope, heading for the Green. The stream forms a natural rock-lined path, silently eroding and carving its way through the soft mud. Stately oaks surround the stream; their thick roots hang suspended in the air where the ground has gradually been washed away. The path turns sharply uphill, passing small waterfalls arrayed like a staircase.

Trees rise through a sea of white flowers, soaking up the first light of a perfectly clear dawn sky. Feathered golden light falls on their massive trunks, trickles down the bark, and spreads outward and downward. The landscape is set ablaze with orange-yellow light as the sun's rays illuminate the flowers, and tiny buds open in anticipation. The forest floor is covered with a fiery sea of light and movement as a gust of wind comes off the river below. It is hard to imagine that all these plants have enough room for their roots. The tall flowers flow in waves of white, while the distinctive trees stand steadfast like sentinels, preserving the harmony that was established long before humans became part of the picture.

The sweeping sunlight highlights the delicate harmony of a forest buzzing with morning activity. Looking closer, one can see snails crawling out from their beds under flower petals, warmed by the bright midmorning light. This nourishing light also warms thousands of insects, allowing them to spread the pollen and seeds of plants. Ants and termites surround a fallen tree, wet and decaying on the forest floor. This deadfall will provide food for thousands as they work to turn waste into usable nutrients. Birds chirp in the distance and are soon plucking insects off the dew-laden leaves. The cycle of life in the forest continues.

Throughout Mammoth Cave National Park, and even beyond the park boundaries, the delicate ecosystem relies on all its members to contribute, and although some are small, their contribution is significant. The primary goal of the national park system has always been to preserve and restore areas of cultural, historic, and natural resources. Through the commitment of its custodians, this park has seen significant improvements since its beginning as a collection of family farms purchased by the government nearly eighty years ago. Through hard work and perseverance, farm fields that were stripped of vital nutrients have been restored, reflecting what the Mammoth Cave region was like before it was settled. Native species have been transplanted and cultivated to replace those that were introduced. Endangered species, such as some freshwater mussels and the Kentucky cave shrimp, have been closely watched and studied. Human impact has been kept to a minimum as we continue to learn the far-reaching effects of just one small change in the ecosystem.

On most days, you won't find the science and resource management specialists at Mammoth Cave in their offices. Their work requires an almost obsessive dedication, and firsthand observation is key. Although visitors may catch only a glimpse of the white government jeeps cruising around the park or a group of specialists hiking the backwoods, these dedicated professionals spend a majority of their time cataloging and restoring even the most remote areas of the park.

With a compass in his hand and a GPS (Global Positioning System) device in his pocket, science and resource specialist Bryce Leech and two volunteers make their way from a remote parking spot on the park's northeastern edge into the heavy brush. Months ago, the park began a program to bring back the American chestnut tree, a species that once flourished in the area but has been steadily declining since the introduction of the Japanese chestnut.

When they reach the plot where a hundred saplings were planted early that spring, they inspect the condition of each of the waist-high trees, looking for physical damage from deer or fungus, and identify which trees are flourishing. All the information is meticulously recorded and will be analyzed later to improve growing conditions and identify the best specimens among the hundreds of trees spread out over several similar plots.

Before Mammoth Cave became a national park, its ecosystem had been negatively affected by development, farming, and pollution. Bringing back native species helps restore the balance, for even a single species can have a widespread effect. This interdependence is both the beauty and the downfall of nature. Fortunately, we now realize that our actions can have a dramatic impact on this delicate balance. Nothing is unimportant, and through painstaking restoration and management, Mammoth Cave not only will survive but will continue to improve as a habitat for its varied wildlife.

Opposite: *Sunrise through oak and hickory forest, Mammoth Dome Sink Trail*

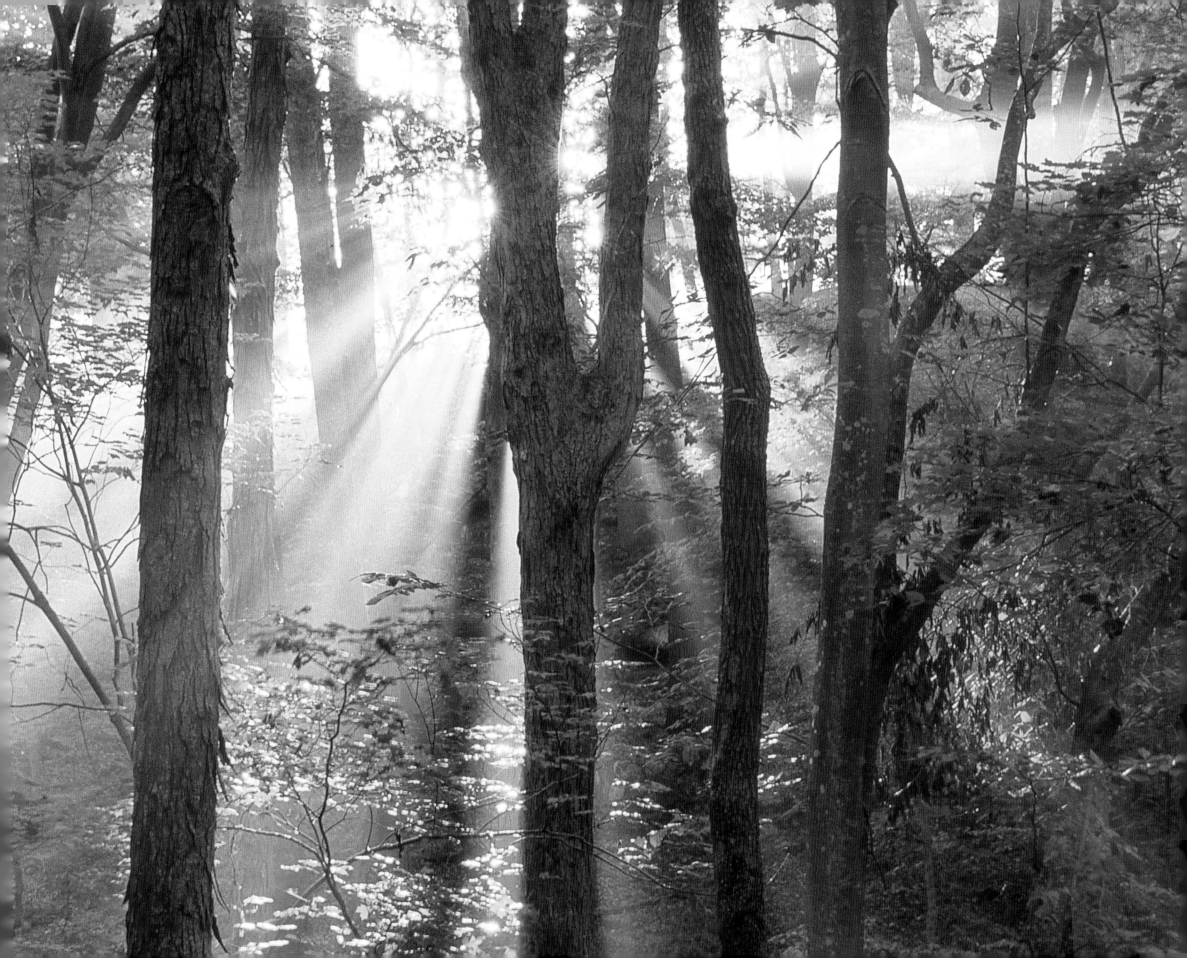

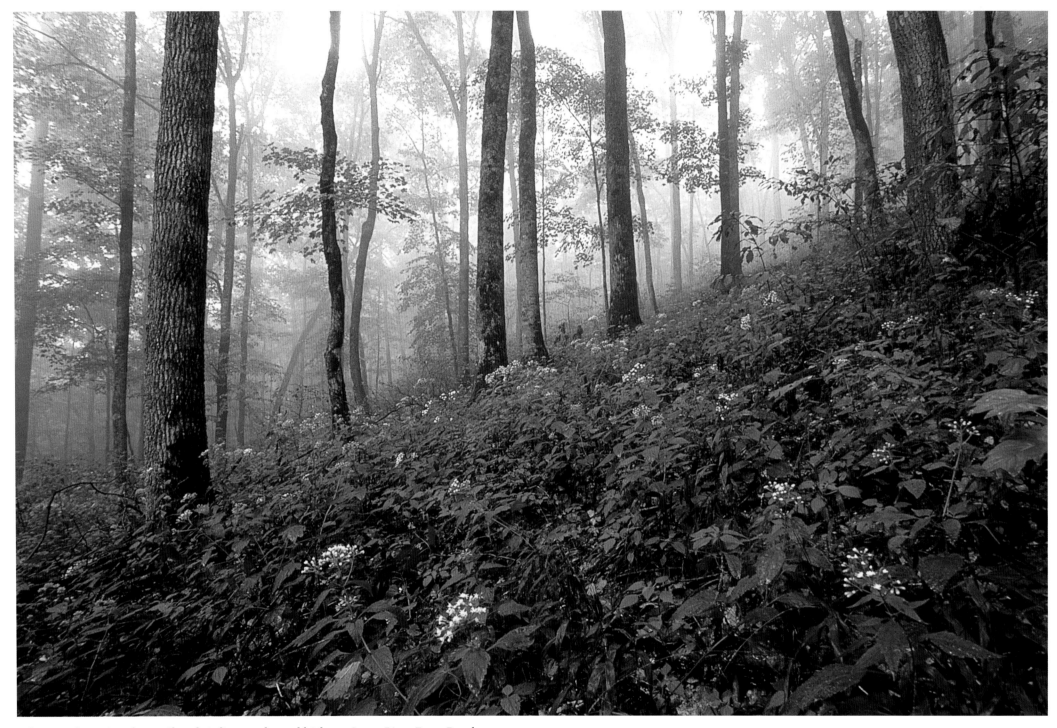

White snakeroot underneath oak, tulip, maple, and hickory, Green River Ferry Road

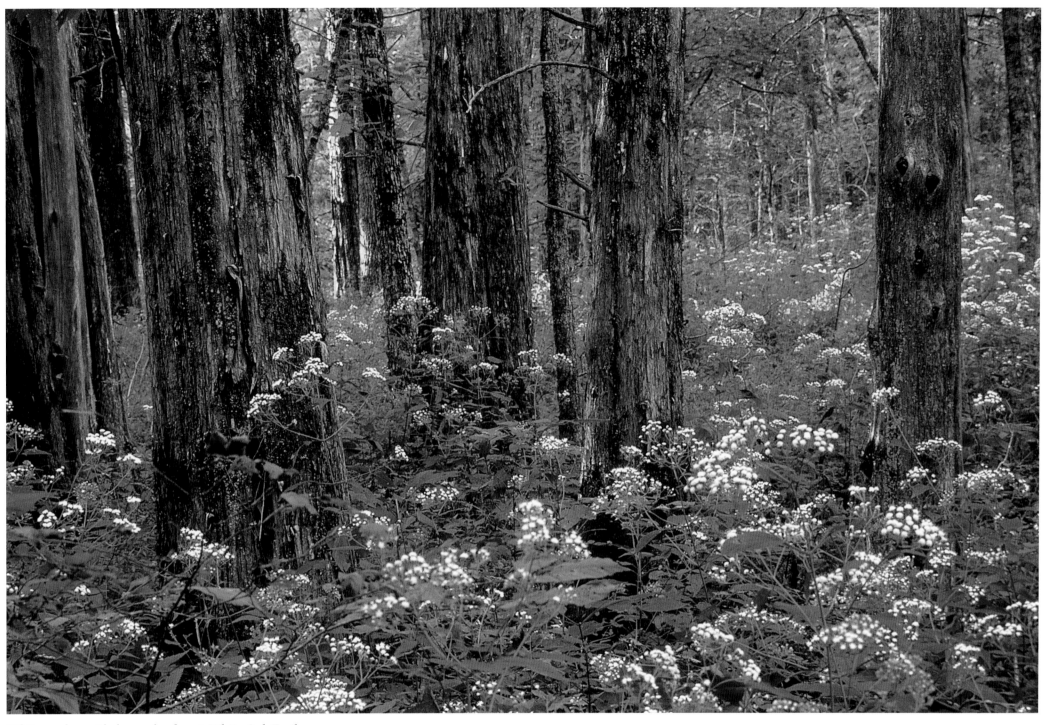

White snakeroot below cedar forest, White Oak Trail

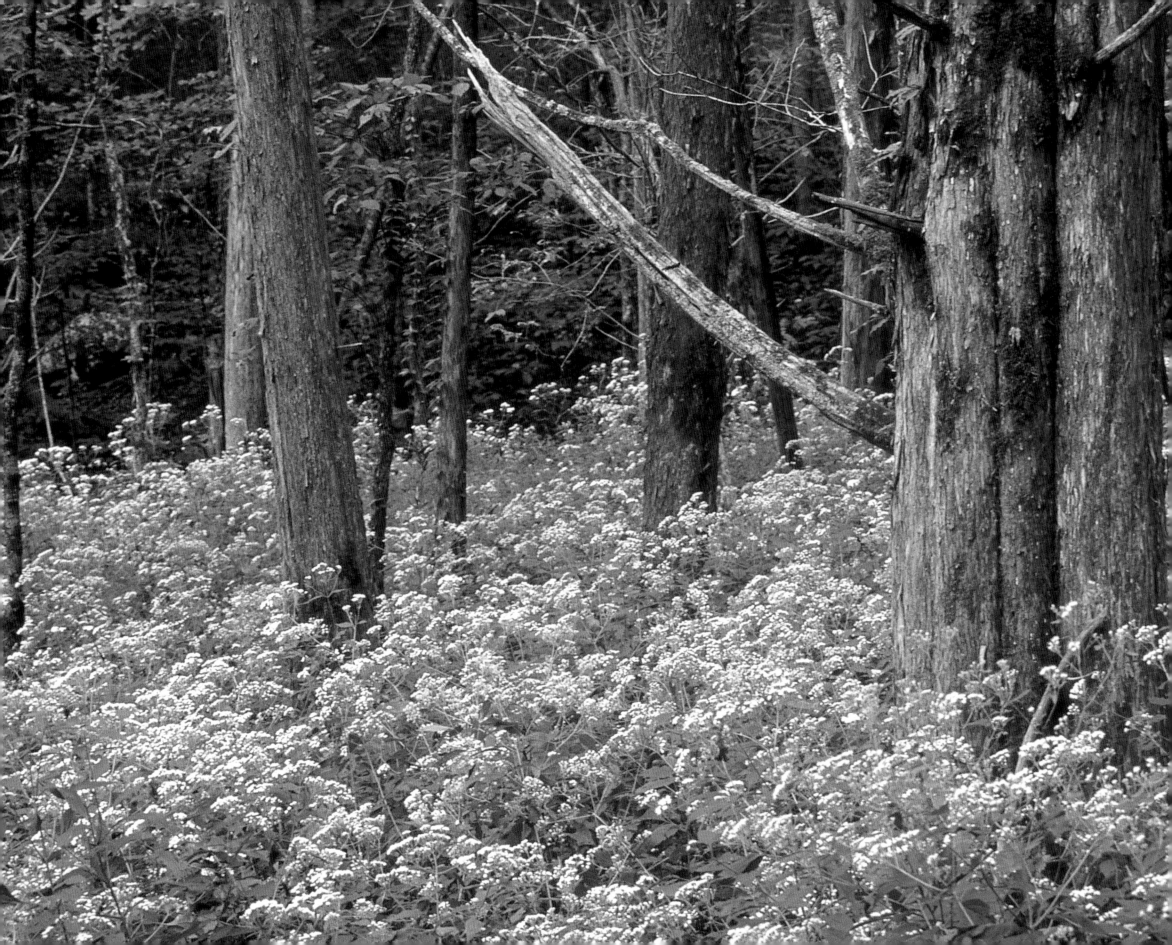

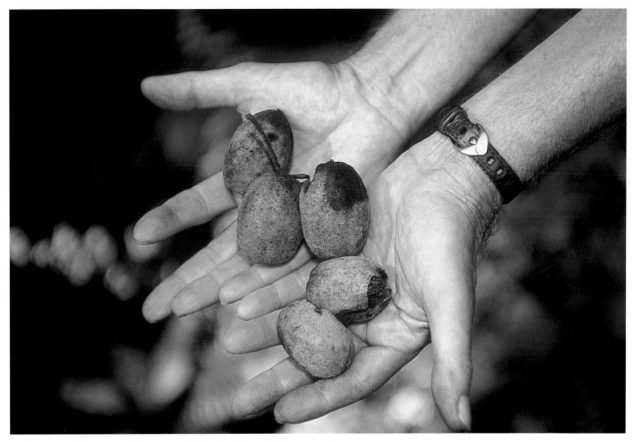

Volunteer Phil Brown showing off the butternuts he found

Cedar, pine, and oak surrounded by white snakeroot, Echo River Springs Trail

89

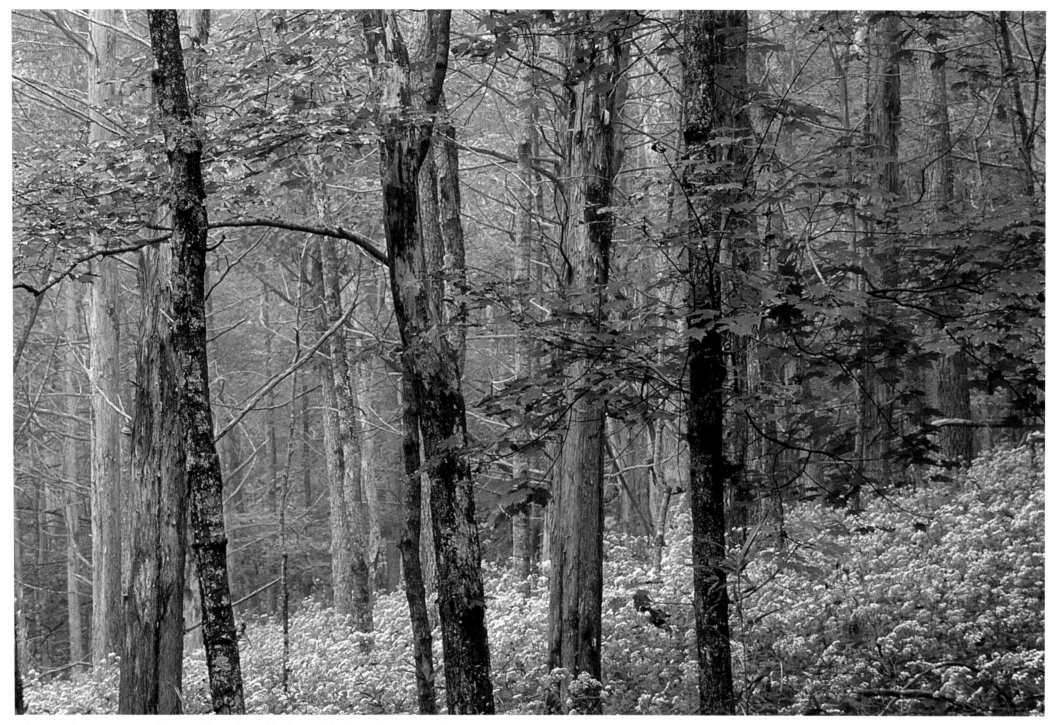

White snakeroot surrounding maple, oak, and hickory, Echo River Springs Trail

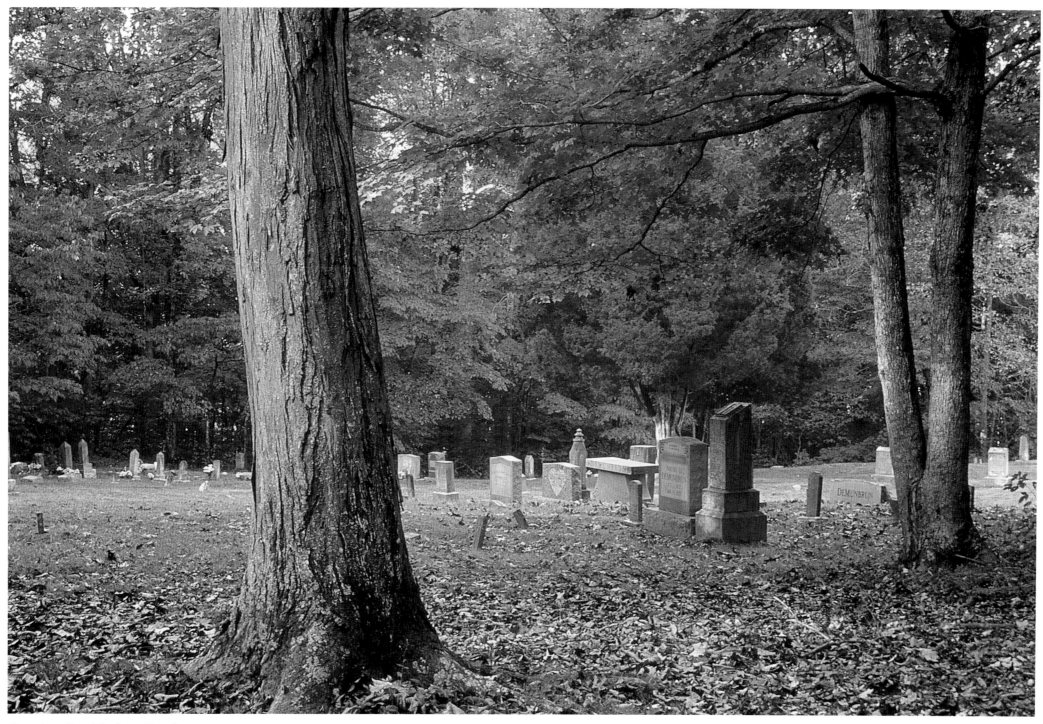

Cemetery, Good Springs Church

Exposed cedar root, Great Onyx Cave Road

Canopy at sunset, Echo River Springs Trail

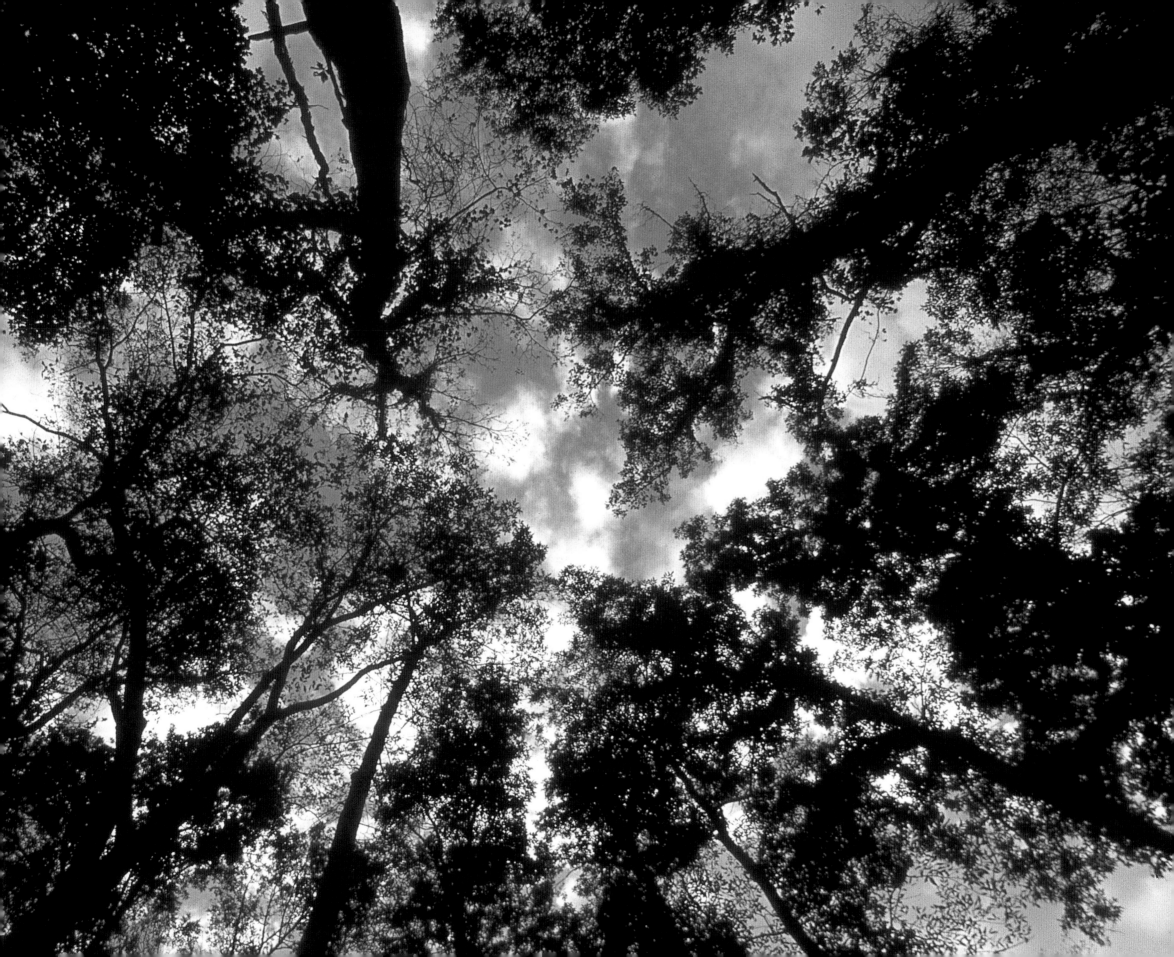

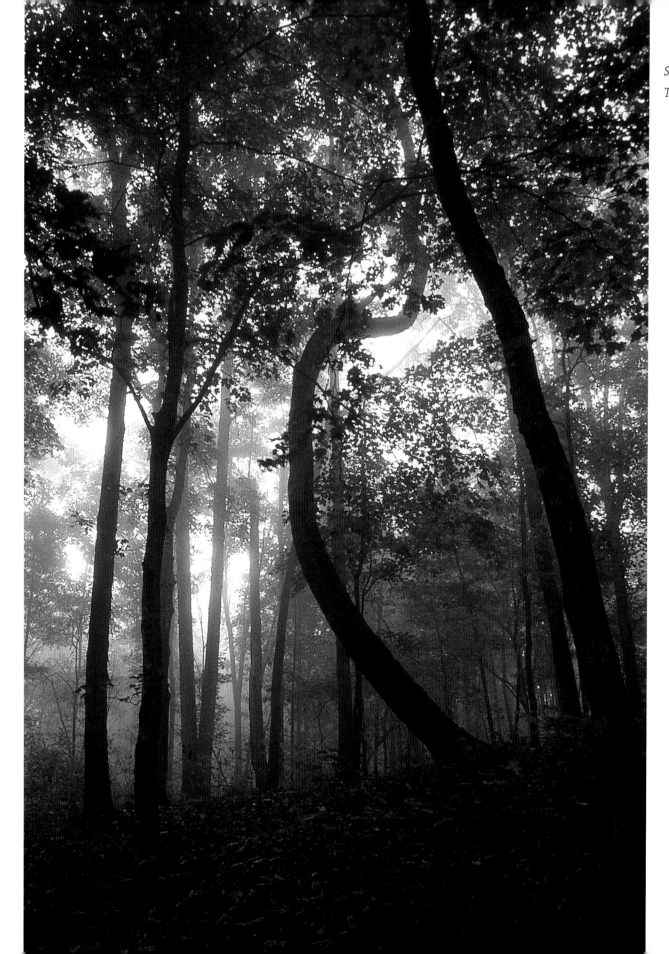

94

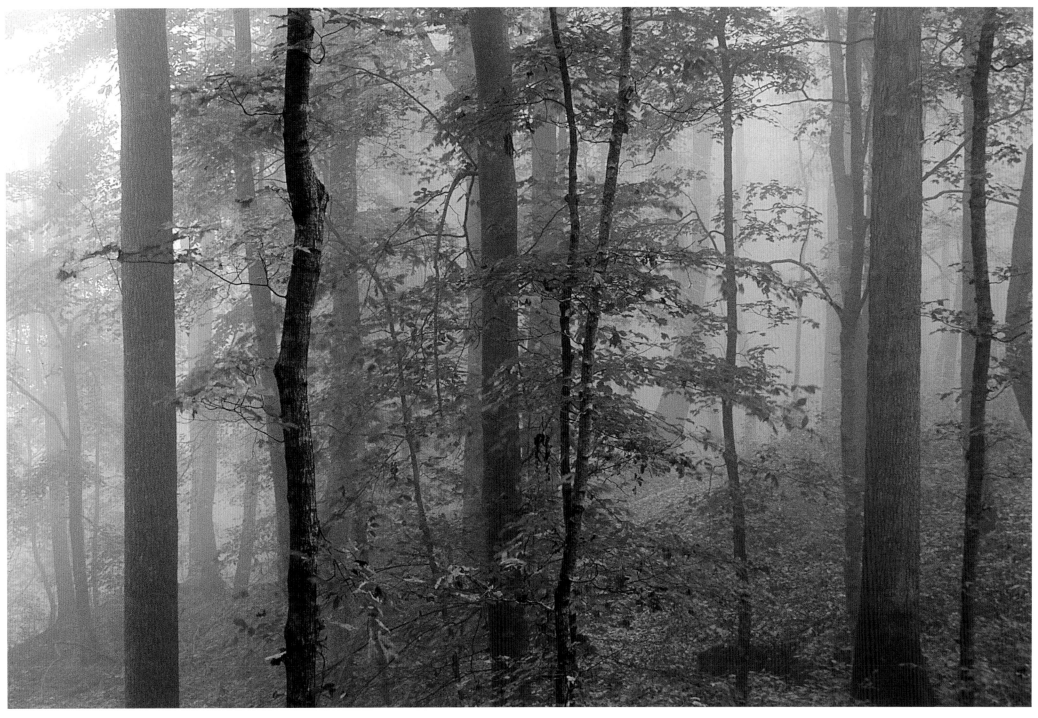

Tulip, maple, and oak forest, Turnhole Bend Trail

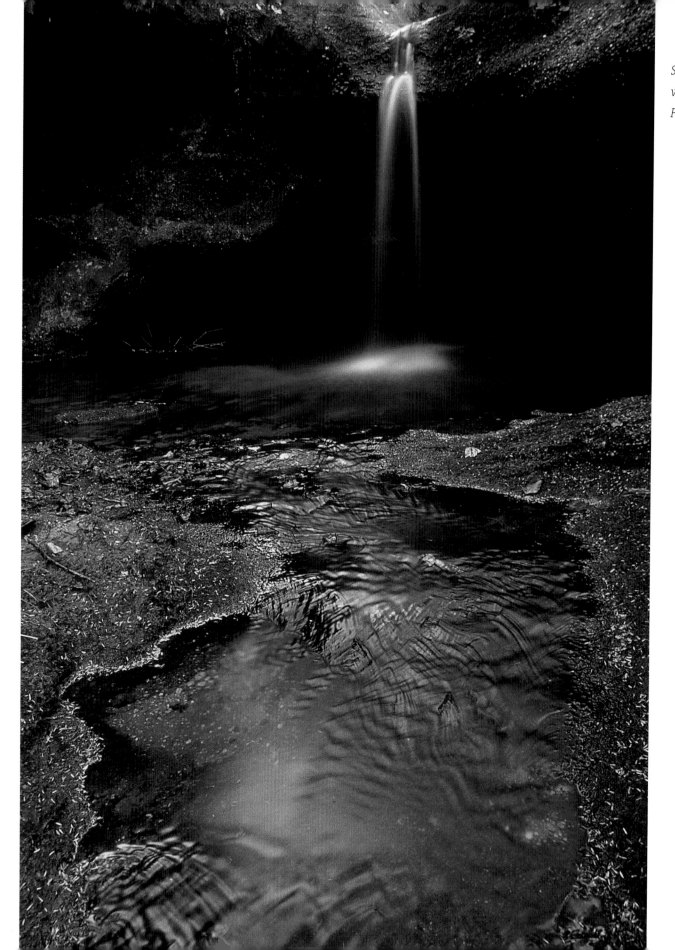

*Sandstone gorge
with waterfall,
First Creek riverbed*

The Miracle of Water

A strong gust of wind shakes the leaves above, bringing down droplets from last night's shower. Worn steps lead to the cave entrance where the popular Frozen Niagara Tour begins, descending to what appears to be the bottom of a great bowl. Water trickles alongside the stairs as the guide opens two doors designed to create an airlock. "Preserving the temperature and specific environment of the cave is our number one goal," the guide explains, elaborating with statistics about the damage done since tours began at Mammoth Cave in the 1800s. With a flip of a switch, lights come on, installed years ago to facilitate tours of the cave. They reveal a long set of stairs disappearing around a sharp corner.

A solid thud resounds through the limestone walls as the door is closed, and the cool, damp cave surrounds us. As our group descends through a series of stairs and landings, the walls glisten with water, reflecting much of the light from the trail. We walk through a maze built around naturally formed shafts, and we can see the vertical path the water took when it formed this section of the cave. Elevated paths now allow access through areas that once required specialized caving techniques.

As the group descends the final steps and crosses a bridge, the nature of the cave changes drastically from tall, vertical shafts to a much smaller, horizontally oriented passage. The cave looks a lot like a large pipe, with smooth walls and gradual indentations throughout. Nicknamed the New York Subway, the passage twists and turns into a large room called Grand Central Station.

The walls once again change from a smooth, polished surface to a ragged, shelflike facade. The water that was so evident throughout the vertical shafts has disappeared, and large boulders that fell thousands of years ago have been moved out of the way to form a path up what appears to be a large hill.

The highlight of the Frozen Niagara Tour is the grand wall of flowstone, which is the single largest formation currently being toured in the park. It was nicknamed Frozen Niagara years ago, an obvious reference to famous Niagara Falls in western New York. This enormous formation was created by the gradual drip of mineral-rich water over tens of thousands of years.

Descending the stairs leads us to the Drapery Room, a small chamber tucked behind the Frozen Niagara formation. A steady flow of water from last night's rain lands in a hole in the cave floor. The guide explains that rain drains into sinkholes, large depressions in the earth that divert water di-

rectly to the water table below. In a karst region, like the one where Mammoth Cave is located, falling rainwater picks up a slight amount of carbon dioxide, creating a mild carbonic acid solution. The combination of carbonic acid and humic acid, which results from water filtering through the ground, dissolves the underlying rock. Limestone is particularly affected by this process, which is responsible for forming all of Mammoth Cave. The vertical shafts at the entry were formed by fast-dripping water, while Frozen Niagara was created by a slow drip.

The passages in the cave were also formed by this water flow, much like the flow of water through a pipe. The water carved a mostly horizontal passage, dissolving rock and enlarging openings, as it drained out of the cave. Evidence of this flow can be found in the scallops, or large indentations, in the walls and floor, which show the direction and intensity of the flow. Mammoth Cave drains into the Green River, which runs through the middle of the park. As the Green River carved its way through the mud and rock, settling lower, it also lowered the water table. The cave thus became a multilevel structure, growing downward to drain into the Green River. Upper levels would sometimes collapse without the pressure from the water, causing breakdown and what we perceive as hills inside the cave. Rainwater drains into the vast system of sinkholes, eventually recharging the streams that flow at the lowest level of the Mammoth Cave system. This balanced ecosystem has created the longest cave in the world because of one key element—a tough sandstone caprock. This thick layer of sandstone protects the limestone in most places from the acidic water, allowing it to enter the cave only at certain places and flow horizontally to the Green River. Without that protection, Mammoth Cave National Park would be a vast canyon.

The water that drains through sinkholes into the underground rivers eventually emerges at several locations, including the River Styx Spring and Echo River Spring. During heavy rains, these springs swell with water, but during drought, there is hardly any spring visible. The water flows out from the ground at these points on its way to the Green.

A unique characteristic of karst areas is the quick disappearance of surface water. In Mammoth Cave National Park—especially on the north side, which is home to several much smaller caves—riverbeds can be overflowing with magnificent waterfalls one day and only a trickle the next. Water flows rapidly through sinkholes, fissures, and cracks almost directly into the underground streams. The nearly direct path of the water into the fragile cave system is an enormous environmental concern. It allows contaminants to reach the cave in a matter of hours. To complicate issues, many of the sinkholes and underground passageways that feed the streams at the bottom of the cave are outside park boundaries. Although they are subject to environmental law, it is difficult to monitor and even to identify exactly which sinkholes drain where. Scientists and resource management

specialists have tried dye tracing to determine the underground drainage patterns in the area, but with a cave system so diverse and complicated, it is an upward battle to try to protect against all possible contaminants.

Mammoth Cave's more than 365 miles may seem like an abundant supply of cave environment, but because of the way it was formed, it is very susceptible to damage. Education and appreciation are the keys to preserving this treasure, not only for generations to come, but also for the many species that call Mammoth Cave their home.

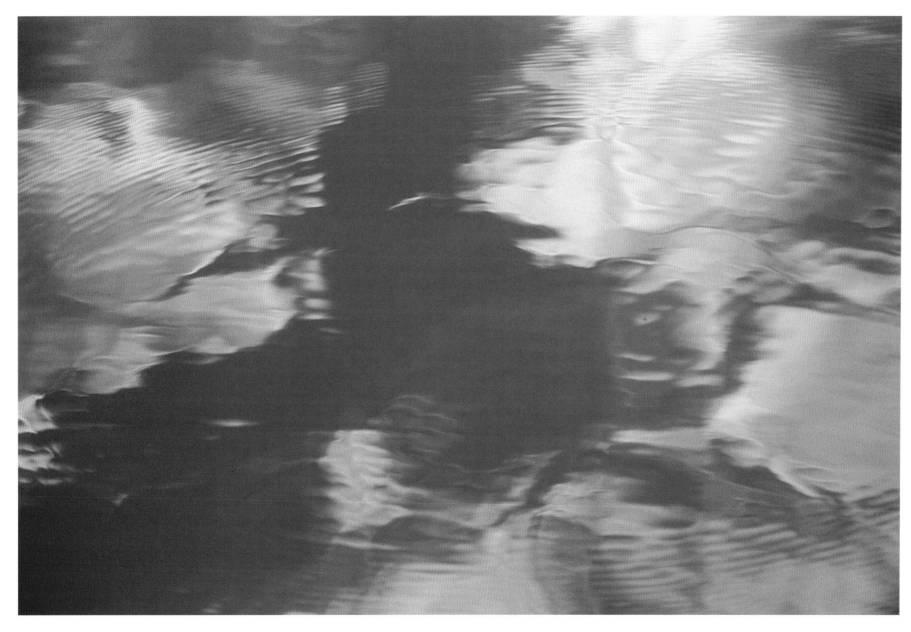

Reflections in the Green River, Houchins Ferry

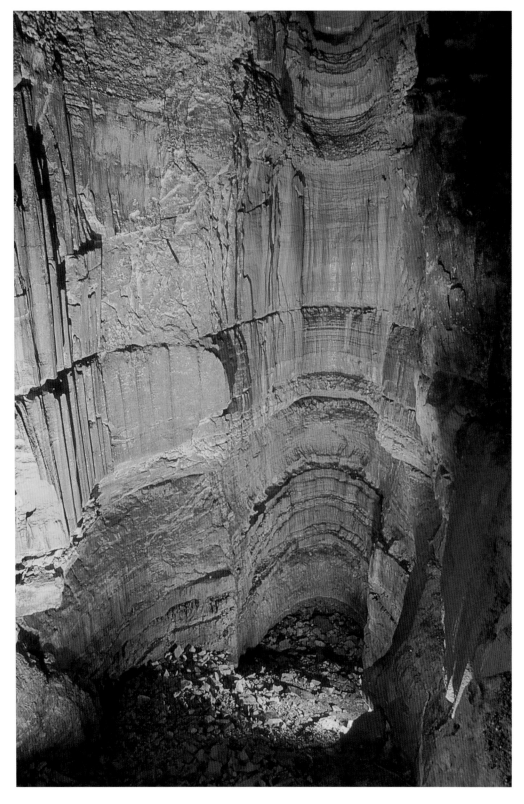

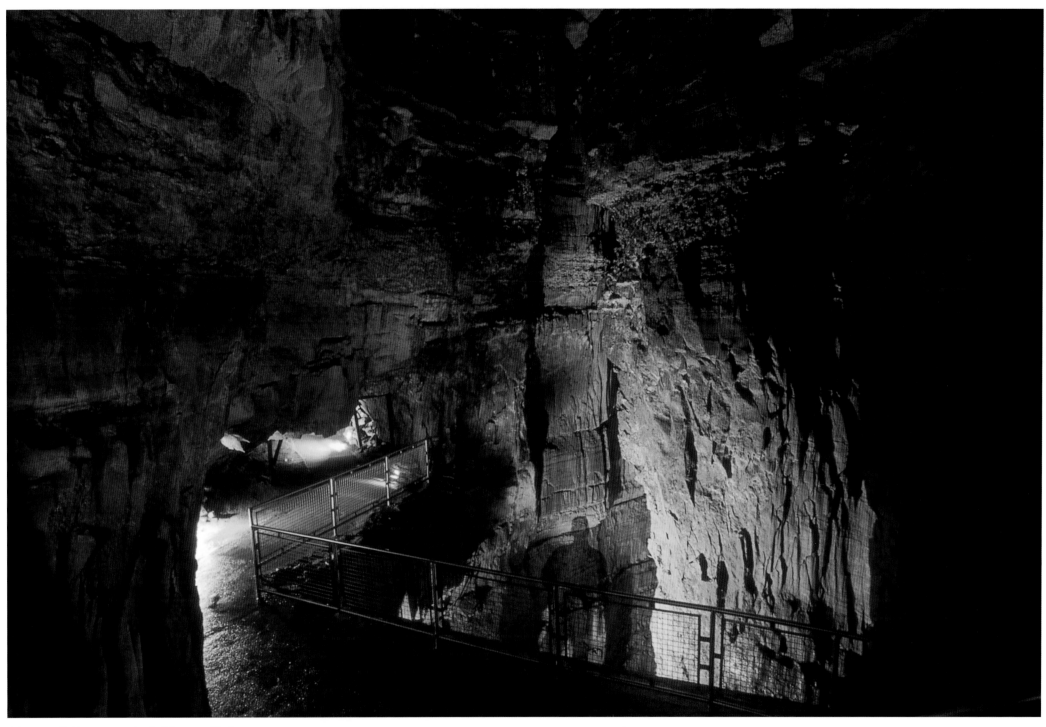

Mammoth Dome overlook, Mammoth Cave

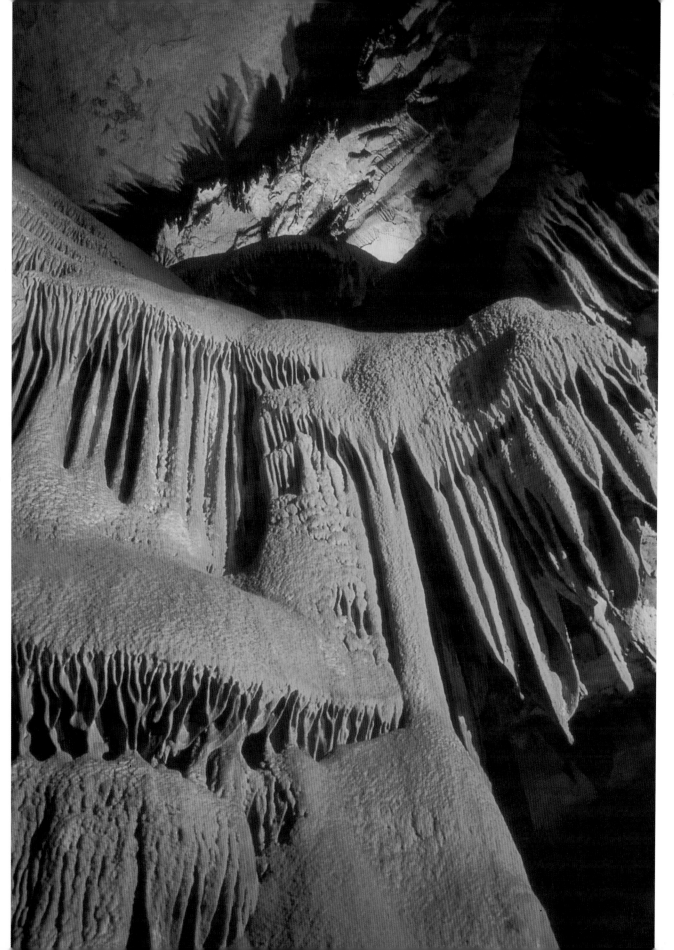

*Frozen Niagara formations,
Mammoth Cave*

The Church,
 Mammoth Cave

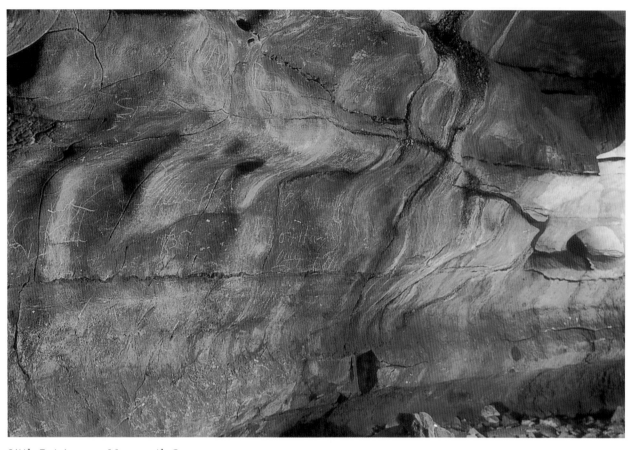

Little Bat Avenue, Mammoth Cave

View from Sharon's Cascade, Mammoth Cave

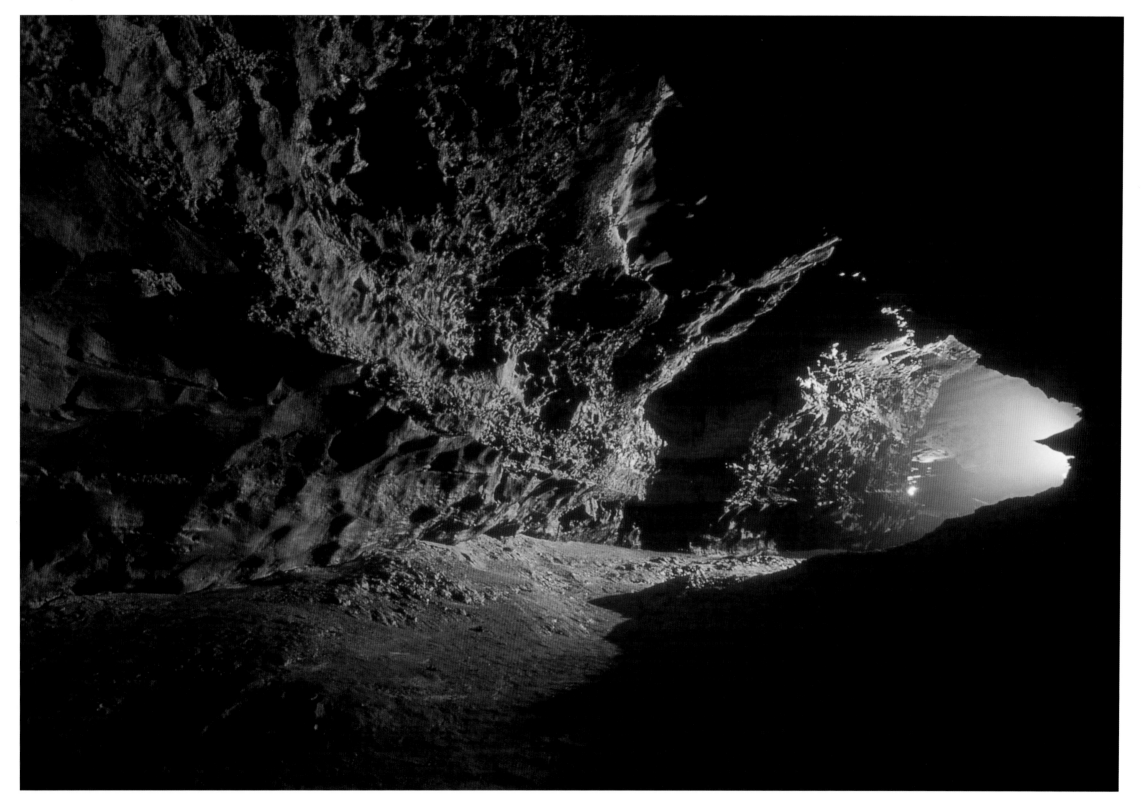

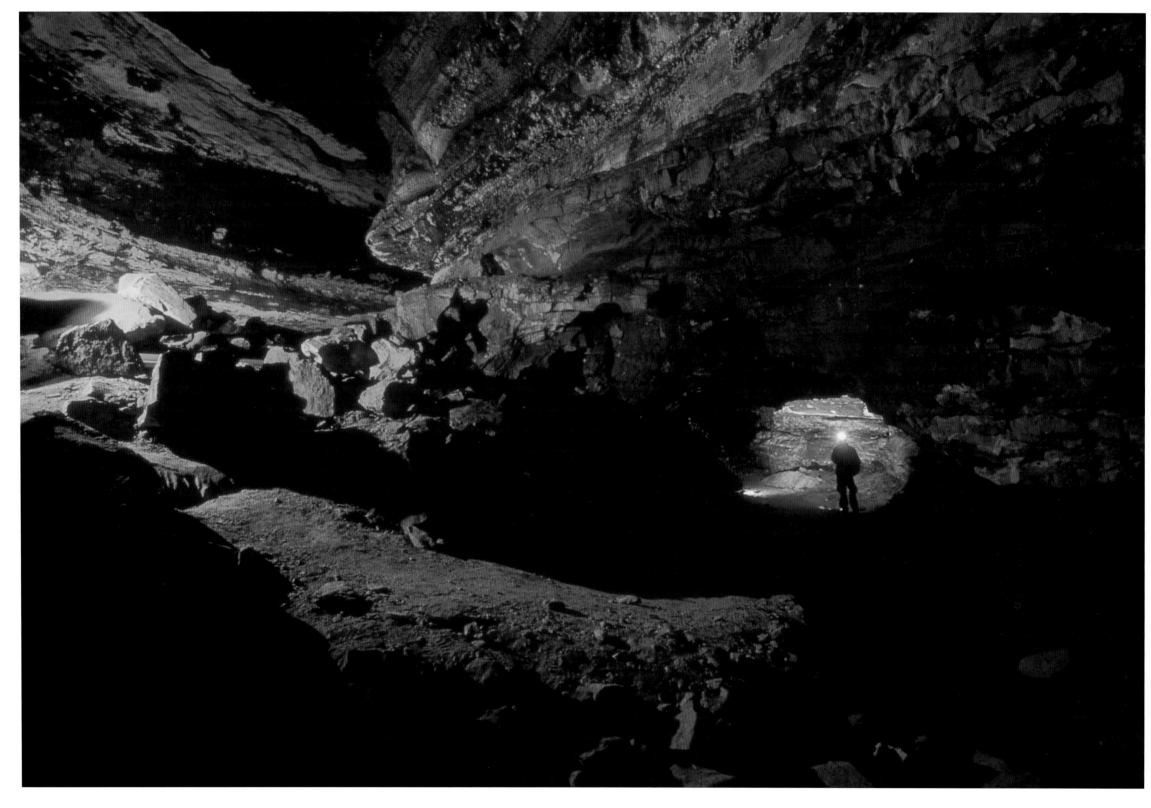

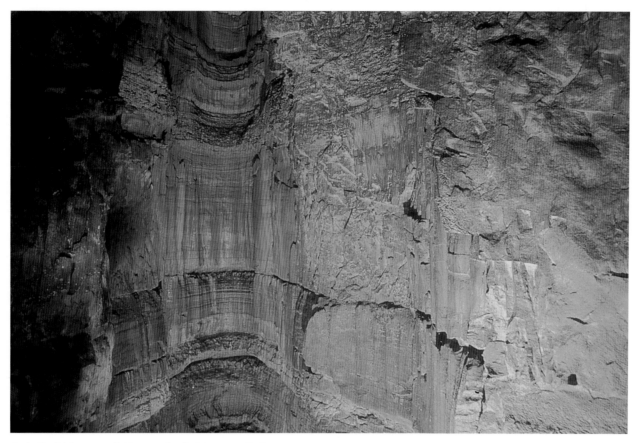

Detail of Mammoth Dome shaft, Mammoth Cave

Star Chamber, Mammoth Cave

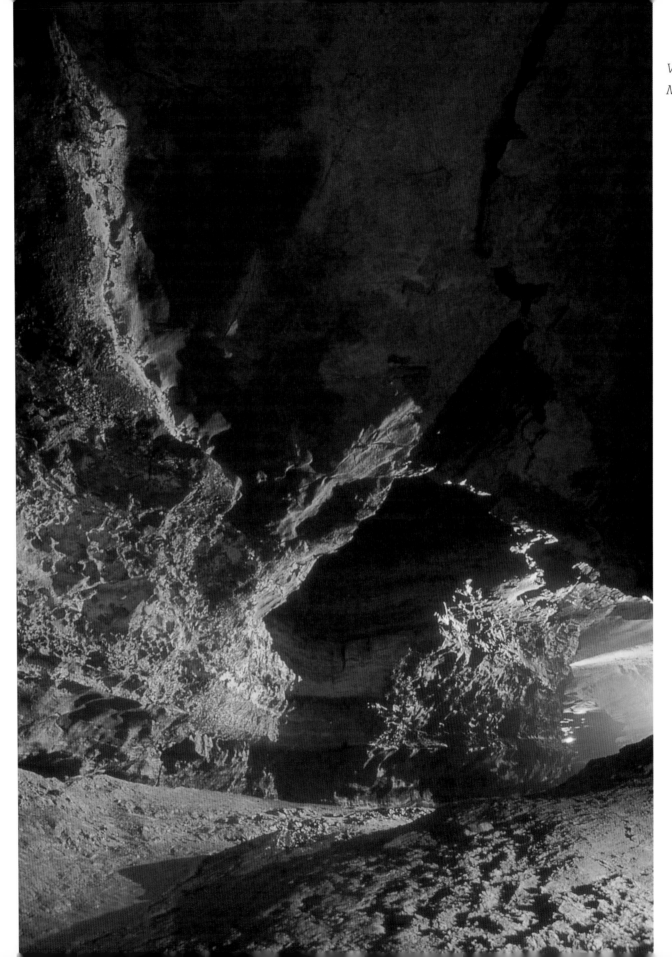

View toward the Dead Sea,
Mammoth Cave

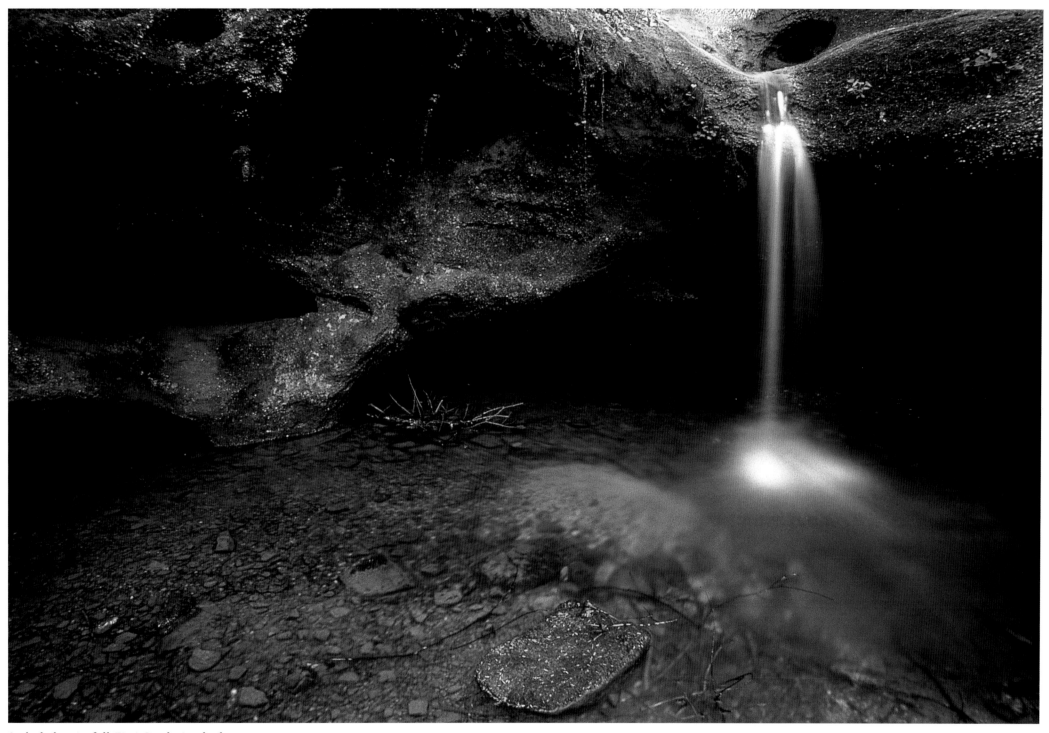

Secluded waterfall, First Creek riverbed

Reflections in the Green River, White Oak Trail

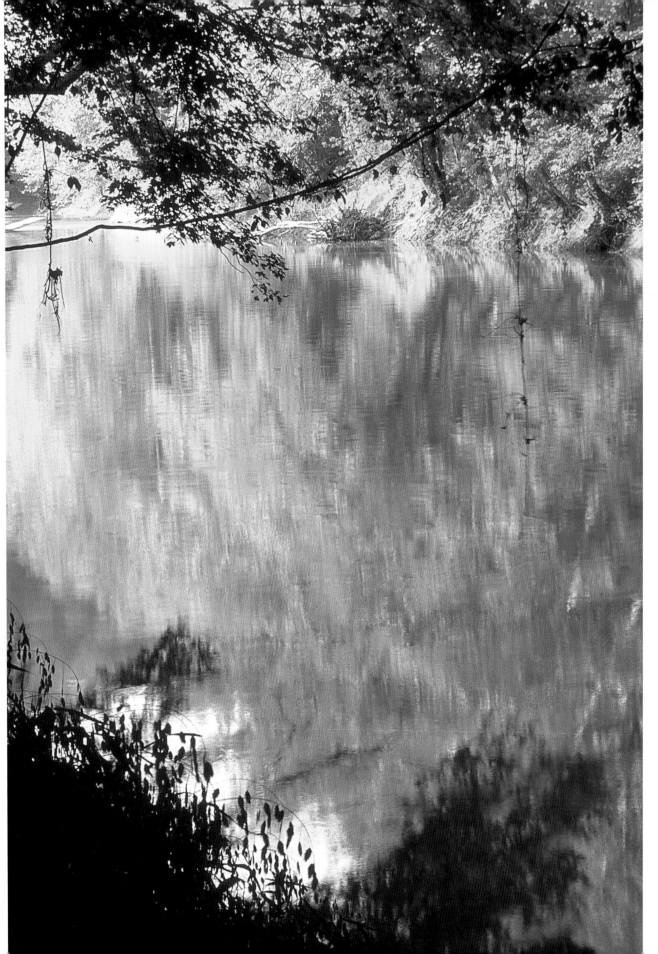

Reflections at sunrise in the Green River, Echo River Springs Trail

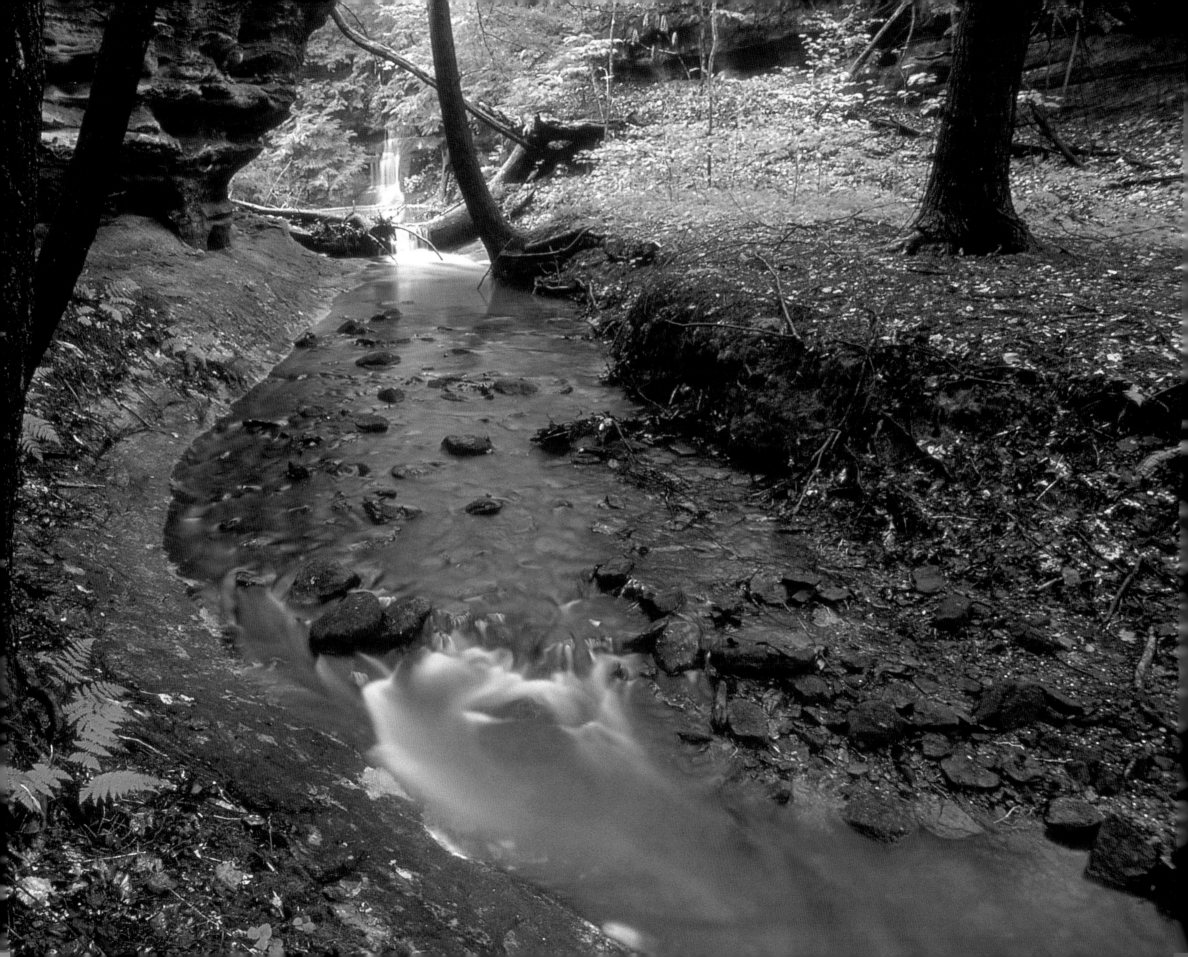

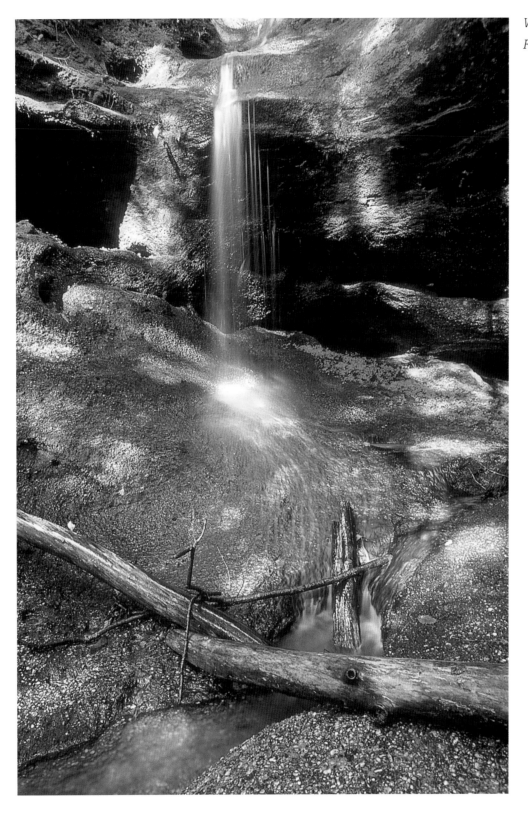

Waterfall over sandstone shelter,
First Creek riverbed

Waterfall and sandstone cliffs,
Wet Prong of Buffalo Loop Trail

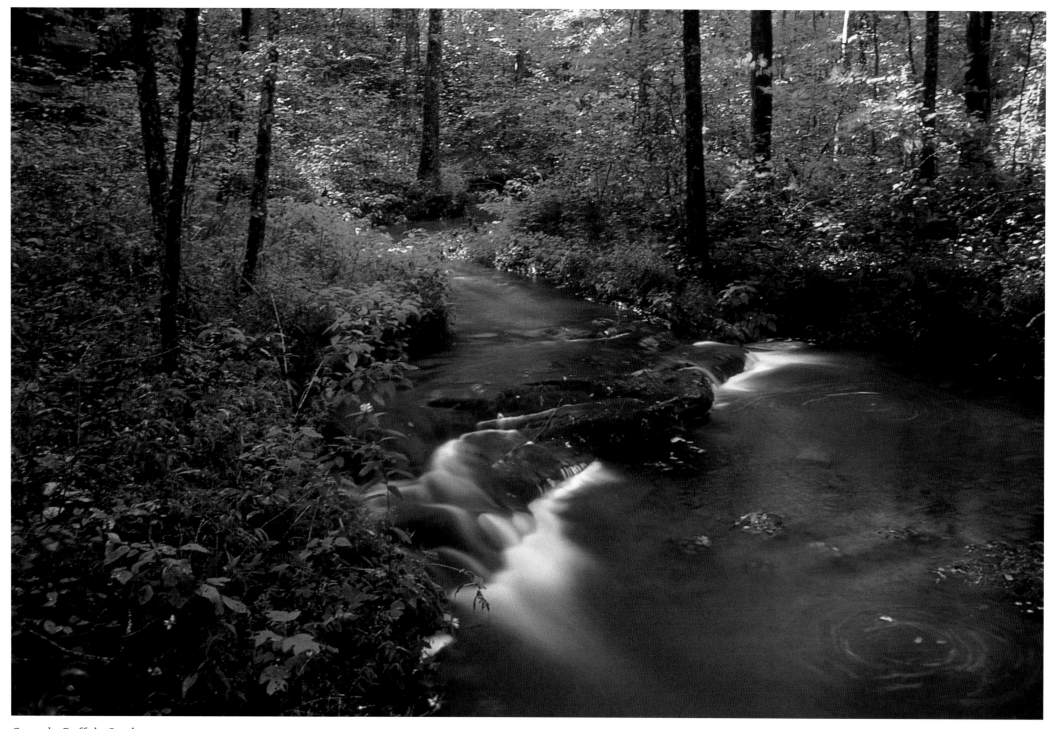

Cascade, Buffalo Creek

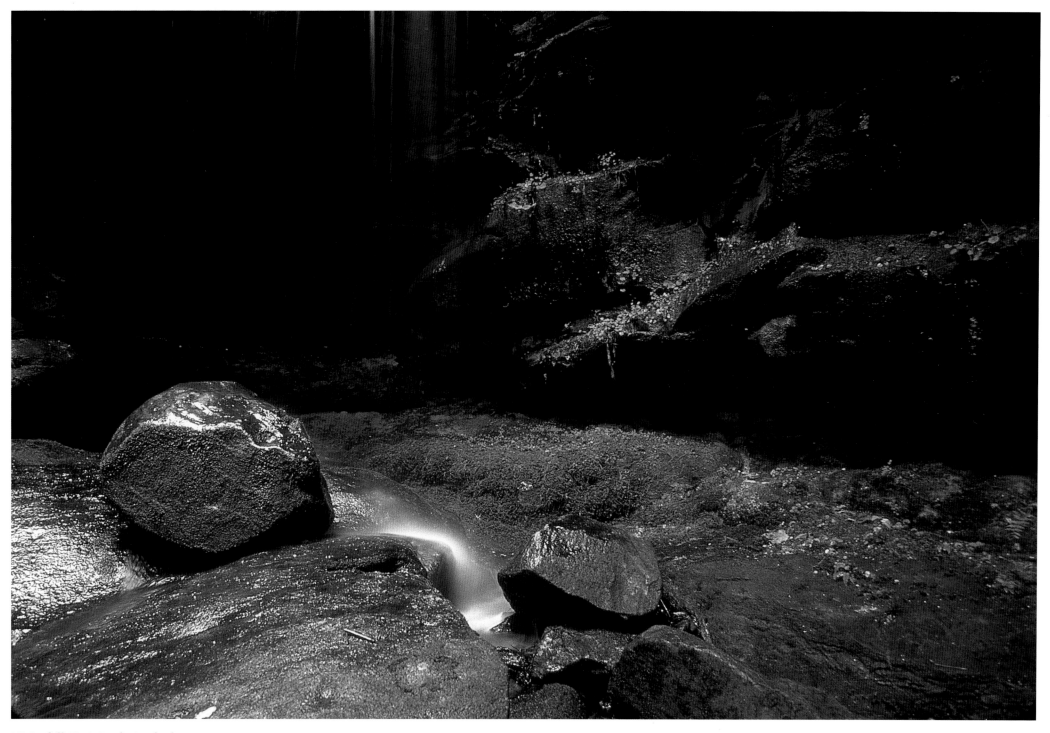

Waterfall, First Creek riverbed

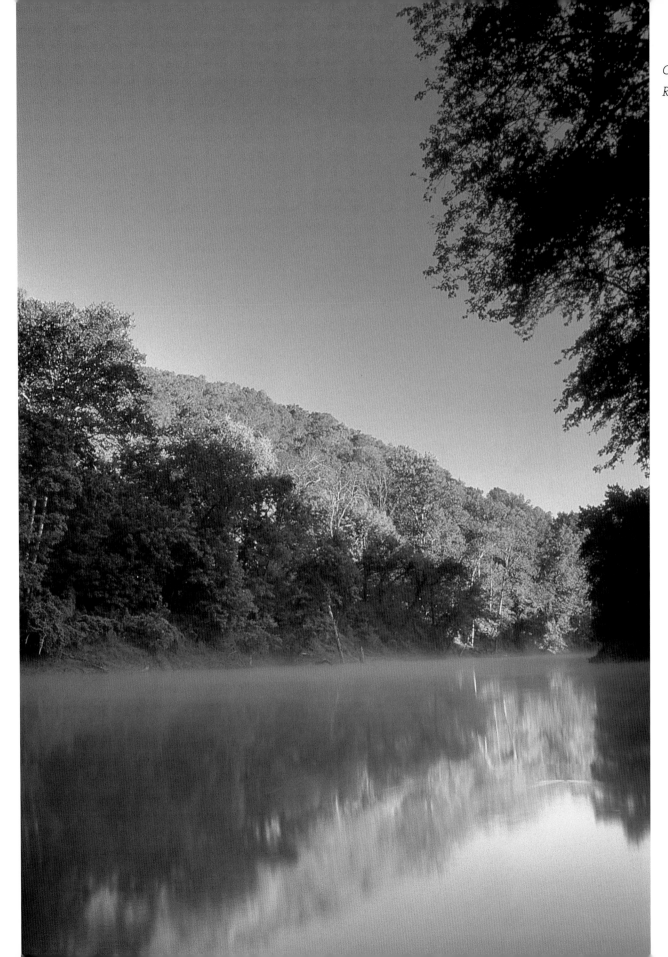

Green River at first light,
River Styx Spring Trail

116

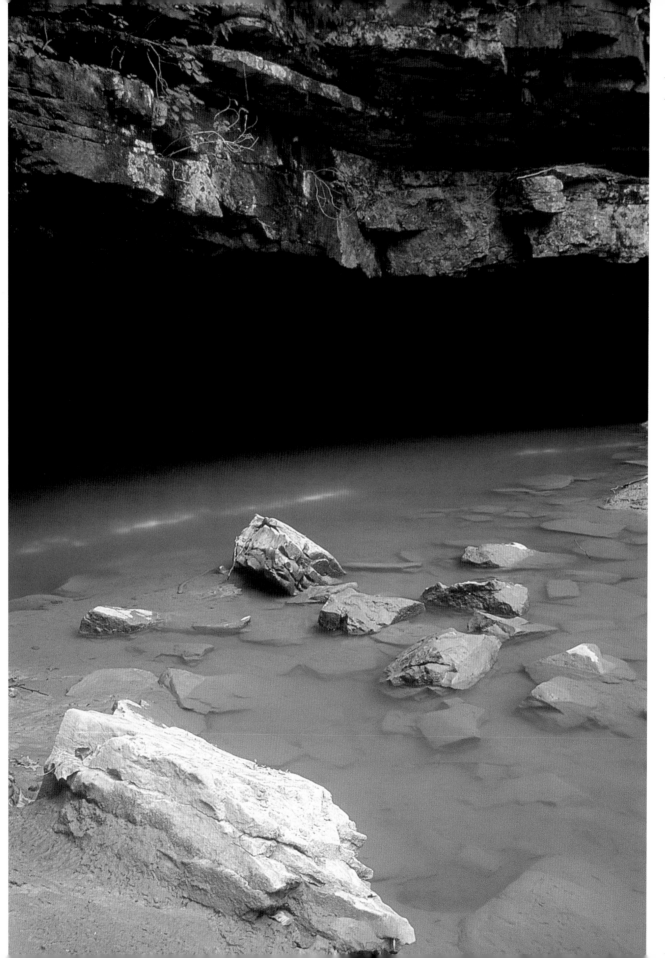

River Styx Spring,
River Styx Spring Trail

117

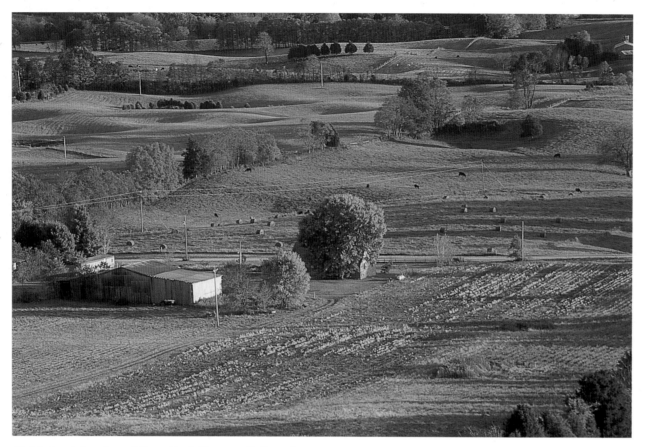

Sinkhole plain, viewed from Park Mammoth Resort

The Green River at sunrise, Echo River Springs Trail

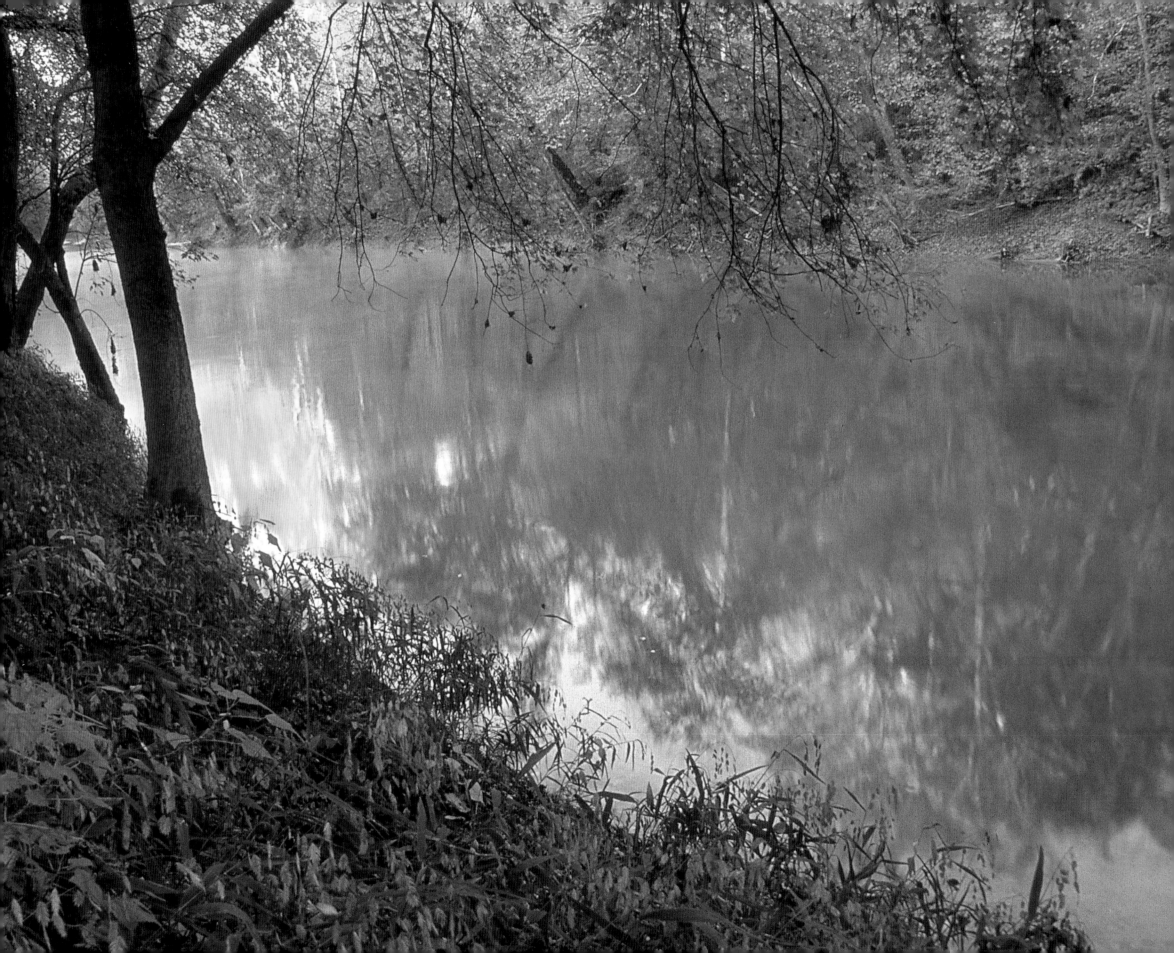

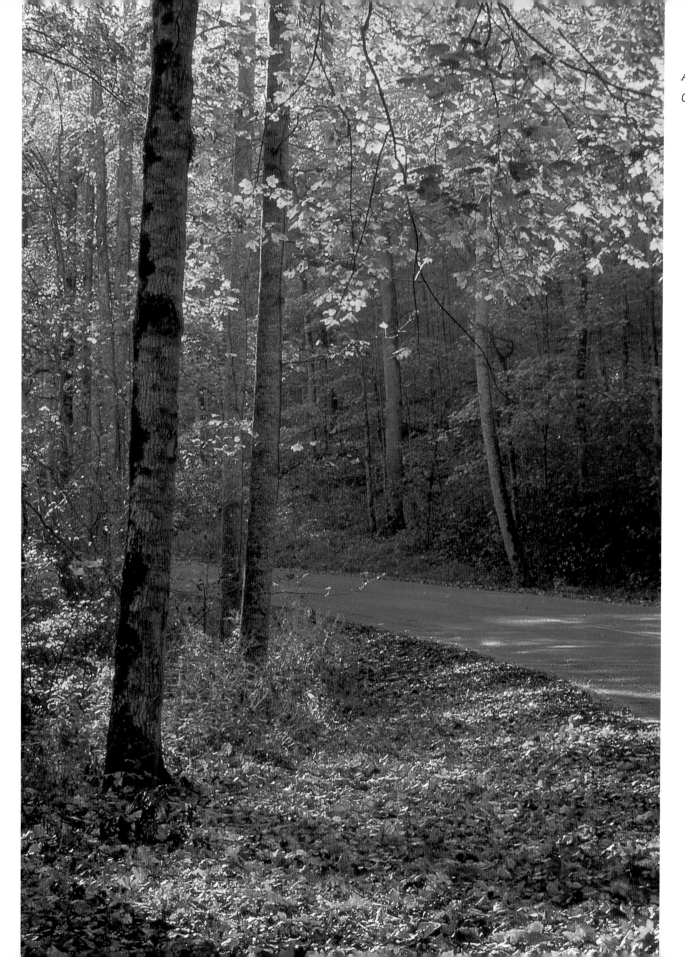

Autumn colors,
Green River Ferry Road